W9-CPB-388

Rothstein, Arthur

Documentary

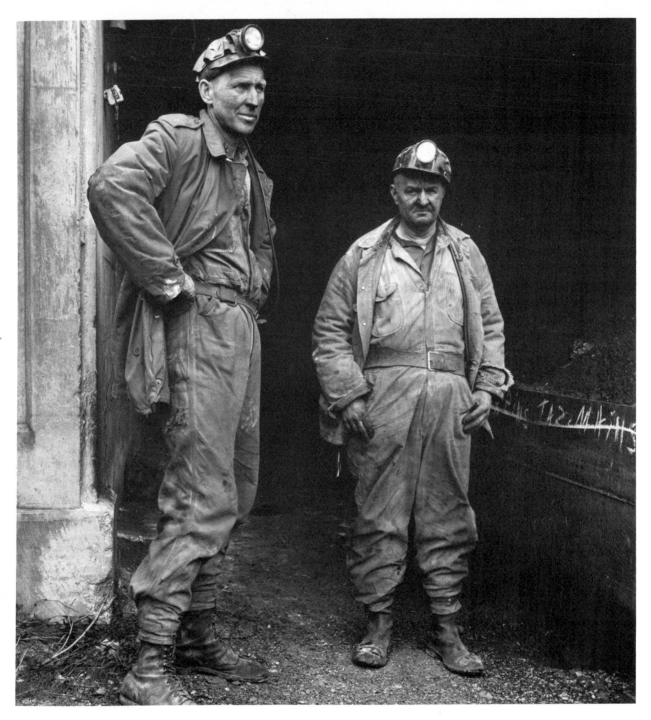

Milton Rogovin: *Coal Miners of Appalachia*, 1965 (© Milton Rogovin)

Documentary Photography

Arthur Rothstein

FOCAL PRESS
BOSTON LONDON

Focal Press is an imprint of Butterworth Publishers.

Library of Congress Cataloging-in-Publication Data

Rothstein, Arthur, 1915–
 Documentary photography.

 Bibliography: p.
 1. Photography, Documentary. I. Title.
TR820.5.R68 1985 778.9'907 85-16640
ISBN 0-240-51754-7

Cover photo: Mary Ellen Mark
Design: Joyce C. Weston
Production: Bywater Production Services

Butterworth Publishers
80 Montvale Avenue
Stoneham, MA 02180

10 9 8 7 6 5 4 3 2

Printed in the United States of America

Contents

Documentary Project the W. Eugene Smith Grant photography in the White House

List of Photographs

CHAPTER 6

CHAPTER 7

CHAPTER 8

Preface

My purpose in writing this book is to describe and explain in words and pictures the evolution and continued development of a distinct form of visual art—documentary photography. I discuss the methods, techniques, and philosophies of documentary photography from those made in the Civil War to the present realistic interpretation of urban life.

Because I am a documentary photographer, I believe that I can evaluate and report, with authority, those trends and directions that are significant. During my fifty years as a photographer, I have had the privilege of meeting with many of the artists described and quoted. This book is also an appreciation of the efforts by these photographers to create art with thought and feeling by understanding the reality before the camera.

The book is chronological in its development with emphasis on those relationships in style that indicate ideological affinities. Although there have been many works on separate aspects of the documentary approach, this volume collects and defines the many and various practitioners in this special field and their influences on each other.

I hope that this book will inspire other photographers, especially those beginning their careers, to pursue the documentary approach. I believe that this type of photography will continue to grow both as an art and a valuable expression of society.

In the preparation of this work, I wish to acknowledge the cooperation and the help of many individuals and institutions. The photographers whom I have interviewed and quoted and who have contributed prints for illustration are the most important and primary sources for this survey.

I have had valuable assistance from the following:

Eddie Adams
Lewis Baltz
Miles Barth
Dan Biferie

Cornell Capa
John E. Carter
Howard Chapnick
Bruce Cratsley

Evelyn Daitz
Lynn Dance
Fred Demarest
Penelope Dixon
Robert Doherty
David Douglas Duncan
Morris Engel
James L. Enyeart
Michael Evans
Ben Fernandez
Jill Freedman
Ken Heyman
David G. Horvath
André Kertész

Ann Lapides
Jack Manning
Mary Ellen Mark
Robert Mayer
Yoichi R. Okamoto
Gordon Parks
Brent Petersen
David Plowden
Milton Rogovin
Walter Rosenblum
Aaron Siskind
Robert Starck
Ted Wathen

The following institutions have been helpful in providing material for this book:

The Library of Congress
Washington, D.C. 20540

The National Archives
Washington, D.C. 20408

The Archives of American Art
41 East 65th Street
New York, N.Y. 10021

George Eastman House
900 East Avenue
Rochester, N.Y. 14607

The International Center of
 Photography
1130 Fifth Avenue
New York, N.Y. 10028

Still Photo Depository
Department of Defense
Washington, D.C. 20310

The Center for Creative
 Photography
University of Arizona
Tucson, Arizona 85719

National Portrait Gallery
Washington, D.C. 20560

NASA Audiovisual
400 Maryland Avenue S.W.
Washington, D.C. 20546

Humanities Research Center
University of Texas
Box 7219
Austin, Texas 78712

The George Arents Research Library
Syracuse University
Syracuse, N.Y. 13210

Witkin Gallery
41 East 57th St.
New York, N.Y. 10022

Susan Harder Gallery
37 West 57th St.
New York, N.Y. 10019

Marlborough Gallery
40 West 57th St.
New York, N.Y. 10019

Zabriskie Gallery
724 Fifth Avenue
New York, N.Y. 10019

Light Gallery
724 Fifth Avenue
New York, N.Y. 10019

Sander Gallery
51 Greene Street
New York, N.Y. 10013

Magnum Photos, Inc.
251 Park Avenue South
New York, N.Y. 10010

Hyperion Press
137 East 38th Street
New York, N.Y. 10016

I have high regard for the advice, support, and encouragement from Arlyn Powell and David R. Guenette, my editors at Focal Press.

My hope is that those who read and study this book will appreciate the unique virtues and attributes of documentary photography. My aim is to inspire others to pursue this approach so that we may remember the past, record our accomplishments, and affirm our faith in humanity.

Arthur Rothstein

Introduction

I<small>N HIS ENTERTAINING</small>, wise, and vivacious book, *The Image*, Daniel J. Boorstin, now the Librarian of Congress, begins his first chapter in this way:

 A<small>DMIRING FRIEND</small>: "My, that's a beautiful baby you have there!"

 M<small>OTHER</small>: "Oh, that's nothing—you should see his photograph!"

Thus, for many of us, the vivid still picture has become more important and significant than reality itself.

In less than a century, a graphic revolution has occurred with techniques for making, preserving, and distributing precise images of people, places, and events.

Photography started as a functional recording device. At his first view of a daguerreotype in 1840, the painter Paul Delaroche said, "From now on, painting is dead!" Delaroche was so enthusiastic about photography that he had his apprentices participate in the very first documentary project in 1851. Under the regime of Napoleon III, this was organized to record the architecture of famous historical churches, bridges, and castles of France. The photographers used the calotype process invented by William Henry Fox Talbot.

But for decades, the photographers continued to imitate painters, and some photographers do this even today. During the nineteenth century, the pictorialists were dominant. It seemed as though the users of the camera suffered from an inferiority complex and could not recognize nor admit to the unique virtues of photography, such as the ability to show detail and stop action. It was in the twentieth century that it became possible for documentary photographers to realize the creative potential of their medium and to achieve full recognition as artists.

In art, one uses the mind, the hand, and the tool. A sculptor uses a chisel directed by the hand and willed by the mind. A painter uses a brush manipulated by the hand and directed by the mind. A pianist uses hands controlled by the mind to play notes on a piano. A writer's mind directs the hands to make words on paper with a pen or typewriter. And a photographer's mind controls

the hand and eye that operates the camera. That is why Ansel Adams described the photographer's art in musical terms. He said that taking a picture was similar to composing music and printing it was comparable to a musical performance. Their acknowledgment as artists does not mean that documentary photographers are working for art's sake. Their results may be technically brilliant and highly artistic, but their primary purpose is to produce a pictorial report.

For many of us, the documentary photographer has become the eyewitness observer of our world and its people. The documentary photographer studies the situation to be visualized and puts into pictures both the knowledge and perception of the subject. These photographs have a more vital quality than mere records, and the photographer will often put into the work personal emotional feelings.

Edward Weston said, "In the application of camera principles, thought and action so nearly coincide that the conception of an idea and its execution can be almost simultaneous. The pre-visioned image, as seen through the camera, is perpetuated at the moment of clearest understanding, of most intense emotional response." This is the way in which the best documentary photographs are produced.

All the photographers discussed in this book have indicated their confrontation, interaction, and interpretation of society. Beginning with Brady, Thomson, and Jackson, each generation's social and cultural values have been expressed through the medium of photography. For Riis and Hine and the FSA photographers, the camera was a means of analysis and persuasion as well as an instrument for social change. The war photographers Capa, Duncan, McCullin, and Eddie Adams described in graphic terms the courage and horror of people in mindless conflicts with a moral lesson for peace. The disorientation of the 1960s was reflected in the work of Frank, Friedlander, Arbus, and Winogrand. Just as Jackson Pollock turned away from conventional painting, these photographers redefined the aesthetics of photography and used new symbols to indicate their awareness of the ugly, banal, and inner preoccupation of their times. Modern documentary photographers are aware of their tradition. They find it satisfying and worthwhile to use the camera to immortalize the commonplace lives of ordinary people.

According to Peter Bunnell of Princeton University, "With ever increasing sophistication, the photographer has represented the content of society. Photography today seems to embody ideas which extend far beyond the actual frame of the picture itself. Today we realize that photography affects us like experience: it shows us what we see."

An important element of the documentary photograph is the fact that it

usually needs words to make its image effective. Many documentary photographs include signs, graffiti, or billboards. Sometimes the words of the subject at the time of the photograph are added. Thus the documentary photograph is a true blend of words and pictures in which the photographs stand independently to carry the message.

The word *documentary* describes a style and an approach. There have been many substitutes suggested—realistic, factual, historical—but none convey the deep respect for the truth and the desire to create active interpretations of the world in which we live that is the documentary tradition.

1. OSCAR G. REJLANDER:
The Two Ways of Life, 1857.
(Royal Photographic
Society)

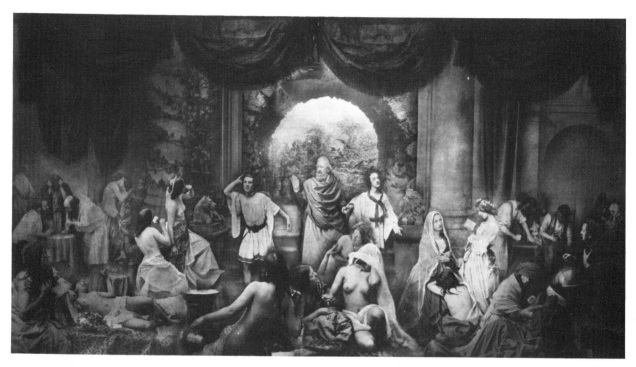

The Documentary Tradition

As applied to photography, the word *document* was first used by Jean Eugene Auguste Atget at the beginning of the twentieth century. On the door of the darkroom in his fifth-floor apartment at 31 rue Compagne Première in Paris, Atget placed a hand-lettered sign, *Documents pour Artistes.* He sold his clear, sharp, 18- × -24-cm (7¼- × -9½-inch) contact prints to the painters Braque and Utrillo and the surrealists. Atget's photographs of street scenes, historical buildings, store windows, and ordinary people served to reinforce these artists' memories of details. They were photographic notebooks for the painter. This quality of authenticity in the unretouched, straight photograph was appreciated by the painter Henri Matisse who wrote in 1908, "Photography can provide the most precious documents existing."

The word *document* is derived from the Latin *docere* meaning to teach. The documentary photograph does more than convey information. It instructs the viewer in some aspect of society in which truth is revealed.

A document is also proof or evidence. The eyewitness quality of the photograph makes it an excellent basis for support of a situation or condition. The leader of the Russian revolution, Lenin, knew this when he declared that "For us, the cinema is the most important art." Thus, it can be understood how the term *documentary* acquired a new significance when applied to the work of filmmakers who pioneered the efforts to influence public opinion during the depression years of the thirties. It is apparent that both the techniques and ideology of many of the documentary filmmakers were influenced by the Soviet films of the twenties. Even before that, Robert Flaherty had photographed life in the remote corners of the world. During the depression he worked with John Grierson in London where he combined his aesthetic and

pictorial talents with the need to explore the harsh realities of the times. Grierson wrote that "the moving picture in the recording and interpretation of fact was a new instrument of public influence which might increase experience and bring the new world of our citizenship into the imagination. It promised us the power of making drama from our daily lives and poetry from our problems."

The Museum of Modern Art in New York City started a film library in 1935 and acquired many of the British documentary films. Paul Rotha, one of the English producers, was invited to show the films and discuss them. As a result, the documentary film was seen not as a crude presentation of fact, but instead as a complex artistic form with reality at its base.

This approach was used in a most effective way by Pare Lorentz who produced two documentary films for the United States Resettlement Administration. *The Plow that Broke the Plains*, 1936, was a dramatic account of the misuse of the Great Plains that led to the creation of the dust bowl. Another film, *The River*, was about the need for flood control and soil conservation in the Mississippi Basin. A third important film, produced by Willard van Dyke and Ralph Steiner in 1939, was entitled *The City* and demonstrated the need for city planning. The documentary film proved that it was able to help people understand the complex world in which they lived by showing how people could relate to their fellowman and the institutions of society. The word *documentary* implied life made meaningful by the creative artist.

Realism and Romanticism

At the same time, in 1935, the Department of Agriculture under its assistant secretary, Rexford Guy Tugwell, formed a photographic unit headed by Roy Emerson Stryker. Photographers were sent to stricken areas to report on conditions with their photographs. The government found that the evidence of the camera could be a great influence for education.

Stryker described documentary photography as

An approach, not a technique; an affirmation, not a negation. The documentary attitude is not a denial of the elements which must remain an essential criterion in any work. It merely gives these elements limitation and direction. Thus composition becomes emphasis, and line sharpness, focus, filtering, mood—all those components included in the dreamy vagueness "quality"—are made to serve an end; to speak, as eloquently as possible, of the thing to be said in the language of pictures. The question is not what to picture nor what camera to use. Every phase of our time and our surrounding has vital significance

and any camera in good repair is an adequate instrument. The job is to know enough about the subject matter, to find its significance in itself and in relation to its surroundings, its time, and its function.

Roy Stryker's rationale for documentary photography resulted from an evolution that started with those photographers who practiced realism rather than romanticism. These two divergent styles emerged during the middle of the nineteenth century. In 1857, the pictorialist Oscar G. Rejlander exhibited in Manchester, England, a composite print from 30 different negatives. It was titled *The Two Ways of Life* and it created a sensation. It showed, as an allegory, the choices facing two young men. They could choose religion, charity, and industry or a life of gambling, liquor, and lust. This romantic photograph impressed Queen Victoria so much that she bought the print.

In 1858, another English photographer, Henry Peach Robinson, produced a composite print, *Fading Away*, made from five negatives. It showed a dying girl in a chair watched sadly by her mother and sister, with her father looking out a window. Robinson's romantic, pictorial approach made him one of the most honored photographers of his time. Through his lectures and books, he influenced many photographers. In one of Robinson's most popular volumes, *Pictorial Effect in Photography*, he said, "Any dodge, trick and conjuration of any kind is open to the photographer's use. It is his imperative duty to avoid the mean, the bare, and the ugly, and to aim to elevate his subject to avoid awkward forms and to correct the unpicturesque. A great deal can be done and very beautiful pictures made by a combination of the real and the artificial in a picture."

Early Documentary Photographers

During this period, in the United States, Mathew B. Brady was photographing the Civil War in a most realistic manner. From 1861 to 1865, the historic photographs made by Brady and his staff of twenty enabled the public to follow the course of battle, to witness the conflict, and to appreciate the devastation of the war. The photographs were converted into engravings and lithographs and printed in the nation's newspapers and magazines. Brady's record of the armies, battlefields, and destroyed cities, made in an objective and unemotional style, is an early example of the documentary approach.

Born in Lake George, New York, in 1823, Mathew B. Brady learned to make daguerreotypes from Samuel F. B. Morse, the inventor of the telegraph and the Morse code. As a step toward fulfilling his ambition to photograph all the notable people of this time, Brady opened a studio in New York at Broadway and Fulton Street in 1844. On February 27, 1860, Abraham Lincoln

Documentary Photography

2. Henry Peach Robinson:
Fading Away, 1858.
(Royal Photographic
Society)

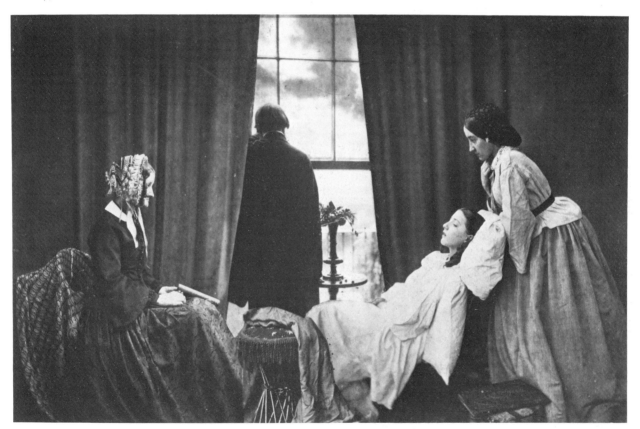

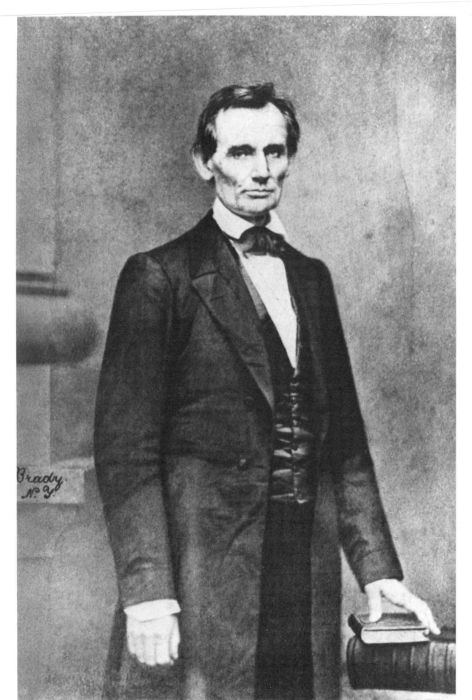

3. MATHEW B. BRADY:
Abraham Lincoln, 1860.
(Library of Congress)

Documentary Photography

4. John Thomson:
Old Clothes Shop, London,
1877.
(Royal Photographic
Society)

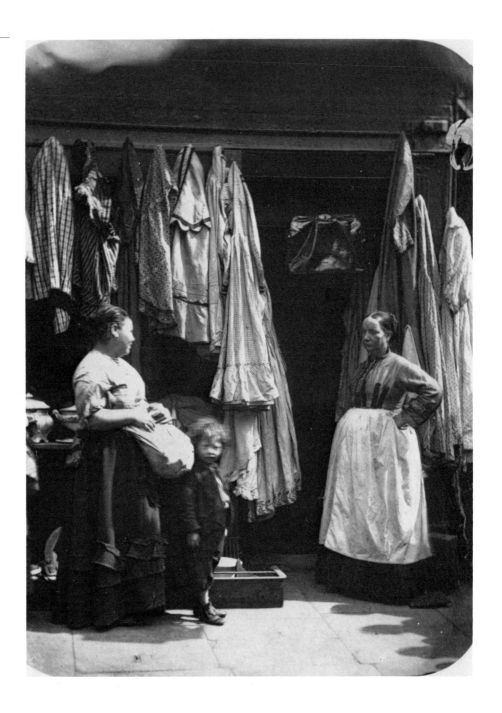

visited Brady's studio after making his famous speech at Cooper Union. The photograph of Lincoln showed him as a man of dignity, strength, and intelligence. It refuted the allegations of his opponents who described him as crude, rural, and retarded. Lincoln said later, "Brady and the Cooper Union speech made me President of the United States." Lincoln's election and the beginning of the Civil War caused Brady to lose interest in collecting pictures of the illustrious. He used all his personal financial resources to document the conflict. The photographs made by Brady and his assistants were produced under battlefield conditions, on glass plates using the wet collodion process. About 7,000 negatives survive in the collection of the U.S. National Archives and the Library of Congress. After the war, Brady was forced to sell all his property and negatives to pay his debts. He died in poverty in a New York hospital in 1896 and lies buried in Arlington Cemetery with the great Civil War heroes whom he photographed.

Another pioneer in documentary photography, John Thomson, worked in a London studio, but made his most interesting pictures of the working classes in their own surroundings. In 1877 he produced with Adolphe Smith a book, *Street Life in London,* illustrated with 36 woodburytype reproductions of his photographs. In their preface, Thomson and Smith wrote that they had used "the precision of photography in illustration of our subject. The unquestionable accuracy of this testimony will enable us to present true types of the London poor and shield us from the accusation of either underrating or exaggerating individual peculiarities of appearance." These photographs were a breakthrough in observation because in mid-Victorian times photographers did not photograph social problems. Thomson recorded the life of the working poor people with sympathy and objectivity. Born in Edinburgh, Scotland, in 1837, John Thomson studied chemistry at Edinburgh University. After his travels to the Far East where he became addicted to opium, he produced many photographic books on China. While working in a professional portrait studio on Grosvenor Street in London, he began to photograph the London working class. He died in 1921 and is considered the first social documentary photographer.

An important and unique aspect of the documentary photograph is its ability to influence people and events. One of the earliest demonstrations of this attribute was the work of William Henry Jackson. In his long and active life, Jackson's most valuable contribution was the use of his photography to help create the national parks. Born in Keesville, New York, Jackson was a veteran of the Civil War and was called "the grand old man of the national parks." In 1866 he traveled west with a Mormon wagon train driving an ox team. He started a photography studio in Omaha, Nebraska, in 1868 and

5. William Henry Jackson:
Great Falls of the Yellowstone,
1872.
(Library of Congress)

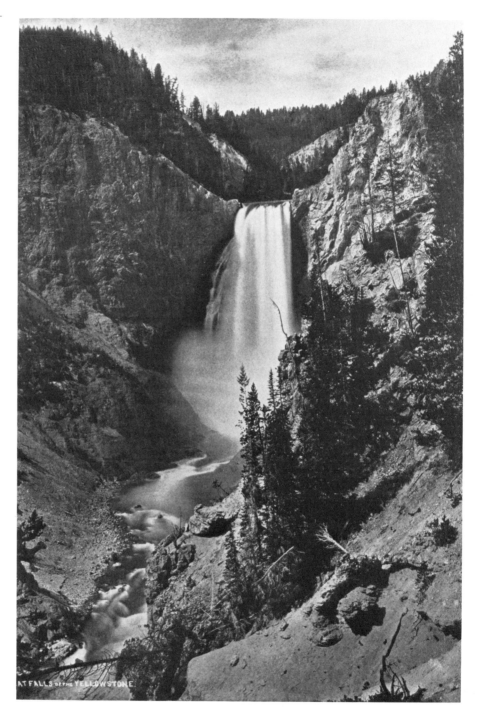

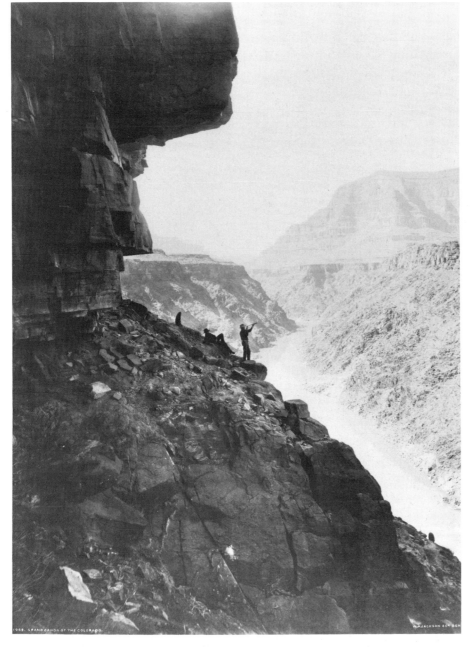

6. WILLIAM HENRY JACKSON:
*Grand Canyon of the
Colorado, 1878.*
(Witkin Gallery)

7. GEORGE E. ANDERSON:
School at Schofield, Utah,
1899.
(Brigham Young University
Library)

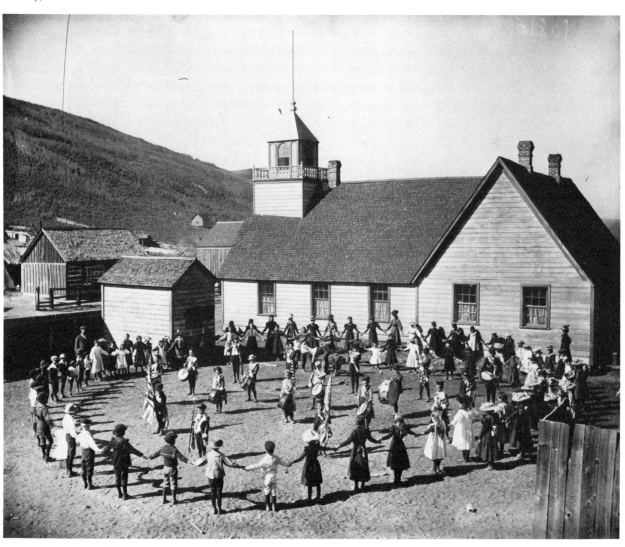

8. SOLOMON D. BUTCHER:
*Rawding Family, Custer
County, Nebraska, 1886.*
(Nebraska State Historical
Society)

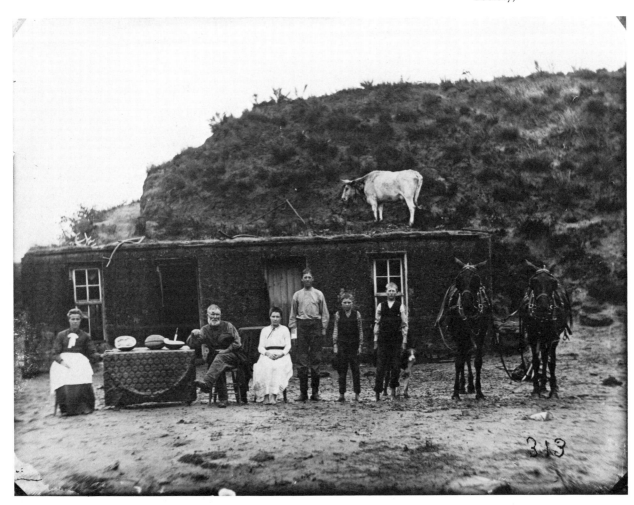

Documentary Photography

9. AUGUST SANDER:
*World War I Officer, Cologne,
1914.*
(Sander Gallery)

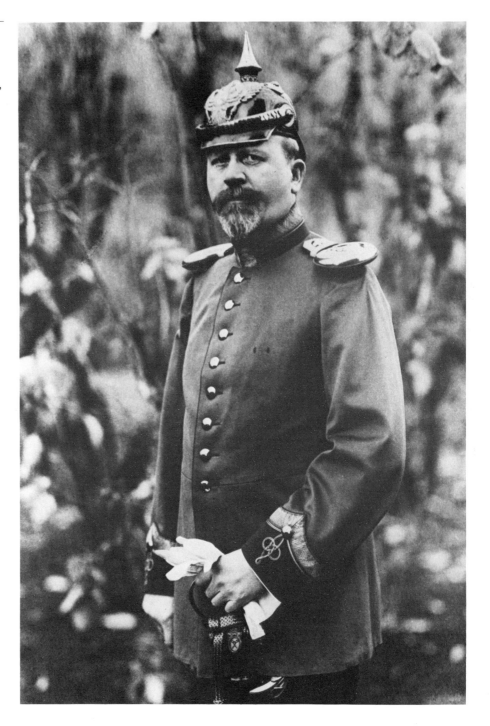

10. AUGUST SANDER:
*Democratic Party
Representative, Cologne,
1928.*
(Sander Gallery)

Documentary Photography

11. EUGENE ATGET:
Street Musicians, Paris, 1899.
(Witkin Gallery)

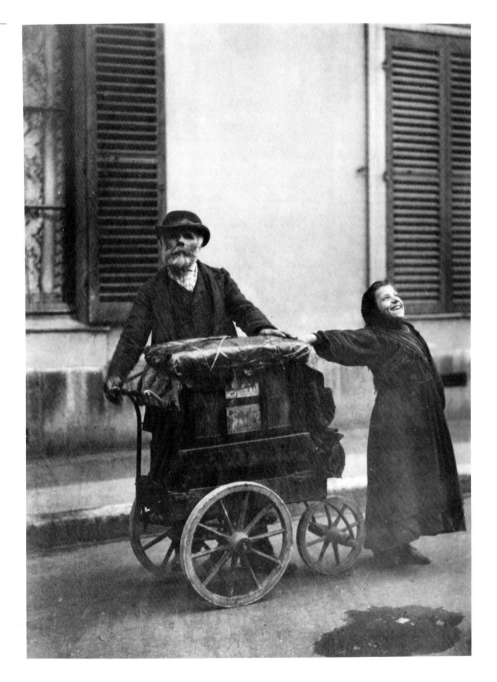

The Documentary Tradition

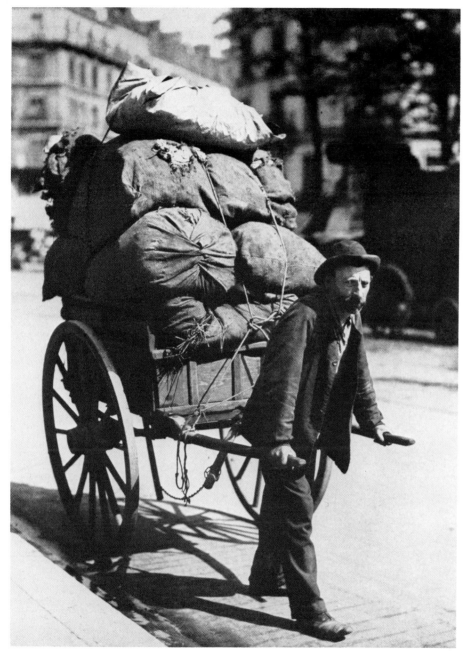

12. Eugene Atget:
Ragpicker, Paris, 1900.
(Rothstein Collection)

13. EUGENE ATGET:
Corset Store, Paris, 1910.
(Chrysler Museum)

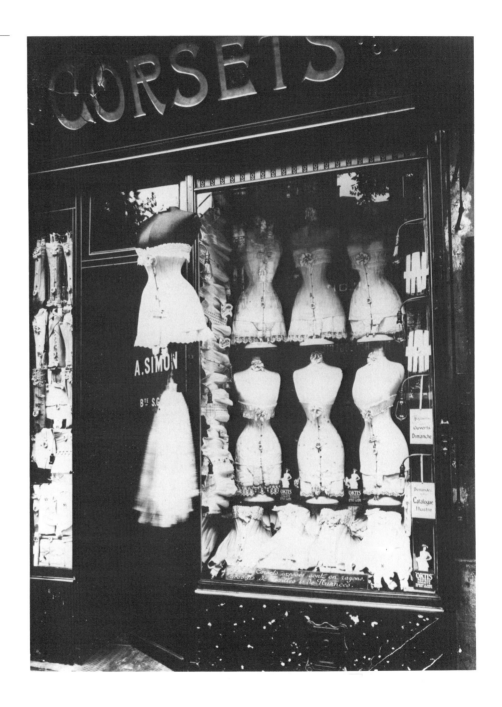

shortly thereafter went on a tour of the newly completed Union Pacific Railroad. From 1870 to 1879 he was the official photographer of the U.S. Geological Survey of the Territories. He photographed in Yellowstone, in the Grand Tetons, in the Rocky Mountains, often with a 20-×-24-inch wet glass plate negative. His photographs of the scenic wonders of the West impressed the United States Congress so much that it set the regions apart as national parks. Between 1894 and 1896, he was a staff photographer for *Harper's Weekly* and traveled across Siberia. He lived to the age of 99 and died in 1942.

In the late nineteenth century, documentary photography was actively pursued on the local level in the western United States. Out of his studio in Springville, Utah, using glass plates up to 14 × 17 inches, George Edward Anderson documented the advance of the railroads and industry, the building of Mormon temples, and the civic celebrations of growing towns. Similarly in Custer County, Nebraska, Solomon D. Butcher made a documentary record that preserved for history the pioneer life and captured in photographs the dignity and fortitude of the men and women who settled the West.

The accumulation of visual information to make a strong and effective statement is one of the assets of documentary photography. An early virtuoso performance with this approach was that of August Sander, considered to be one of Germany's finest photographers. Born in 1876, Sander had a studio in Cologne. In 1910, he started an ambitious program to photograph representative people of Germany from all classes and occupations. He called his project, *Man in the Twentieth Century*. With great objectivity, Sander produced a collective portrait consisting of 40,000 negatives showing the personalities of his subjects without pretense or artifice in a direct, straightforward manner. Many of his photographs were destroyed by the Nazis because his images did not conform to their ideal of the Aryan race. He died in 1964 and his son saved enough of his work to appreciate the skill with which he not only created a likeness but was also able to penetrate the character of his subject.

Of all the precursors of modern documentary photography, it is Eugene Atget who epitomizes those special qualities that make the documentary tradition unique. During a career in photography that started in 1898 and continued until his death in 1927 at the age of 70, Atget showed a universal genius. He was discovered and recognized late in his life, in the 1920s, by three American photographers, Man Ray, Berenice Abbott, and Ansel Adams. It was Berenice Abbot who photographed him and later bought the contents of his studio, preserving about 5,000 of his prints and 1,000 glass plate negatives. This collection was purchased in 1968 by the Museum of Modern Art in New York City.

Eugene Atget was born in Libourne, near Bordeaux, France, in 1857.

Until he was 42 years old, he worked as a sailor, an actor, and a painter. He had only one close relationship and that was with an actress ten years older, named Valentine Compagnon, with whom he lived from 1886 until she died forty years later. He lived a simple life. For twenty-nine years, he would start out in the morning, often before dawn, to capture the morning light on the silent streets. His equipment was simple, too. Man Ray said, "Atget worked with an old 18- × -24-cm camera and a brass rectilinear lens. No shutter was used—just a cap over the lens. He had no interest in photography as an art of progress. He was guided by his emotions and not by any desire to astonish."

By the afternoon, Atget was back home, ready to work into the night in his darkroom. His glass plates were printed by contact on printing-out paper and toned with gold chloride. Later, these delicate, full-gradation prints were termed "aristo types." He sold more than six thousand prints at modest prices to the museums, libraries, and the artists of Paris. Atget's style of photography was described by Ansel Adams in 1931: "His work is a simple revelation of the simplest aspects of his environment. There is no superimposed symbolic motive, no tortured application of design, no intellectual axe to grind."

Atget's work and attitude toward photography parallel and reinforce those traditions that have created the documentary approach.

1. A straight, simple, realistic technique uncluttered with visual aesthetics and avoidance of manipulation
2. The finding of significance in the commonplace and ordinary, implying a valid representation of conditions
3. The revelation of truth through the proof and evidence of the camera
4. A concern for social issues and causes at all levels of society
5. The production of honest photographs that are useful, functional, and serve the purpose of education and information
6. Photography that moves people and influences them to act positively

The Concerned Humanists

T HE SUBJECT MATTER of documentary photography is unlimited, but not every photograph is documentary. It should convey a message that sets it apart from a landscape, a portrait, or a street scene. The recorded event should have more significance than a snapshot. It should reveal more of a person than a likeness. The documentary photograph tells us something about our world and makes us think about people and their environment in a new way. In the nineteenth century, the photograph was a substitute for reality, and this was sufficient to make an impressive impact. But with time, the increased awareness of the viewer demanded more artful techniques.

Photographers and Social Reform

The reality seen before the lens by the documentary photographer is recorded objectively on the sensitive emulsion with a comment by the photographer on the truth perceived. This approach had led to the further development of documentary photography as an important medium of expression. Some photographers discovered that photographs could cause change and that their visual observations could reflect their strong convictions. Edward Steichen said, "The mission of photography is to explain man to man and each man to himself."

The camera's power to hold up a mirror to society was used by John Thomson in 1877 when he photographed the poor people of London and became one of the earliest documentary photographers.

In New York City, a reporter for the *Tribune* and later for the *Sun* showed how photographs could be used in a campaign for reform. Jacob Riis, born in Denmark in 1849, arrived in New York City in 1870. For three years he was unemployed and destitute until he got a job as a police reporter for the *New*

Documentary Photography

14. Jacob Riis:
Night School in Seventh
Avenue Lodging House, 1894.
(Museum of the City of New
York)

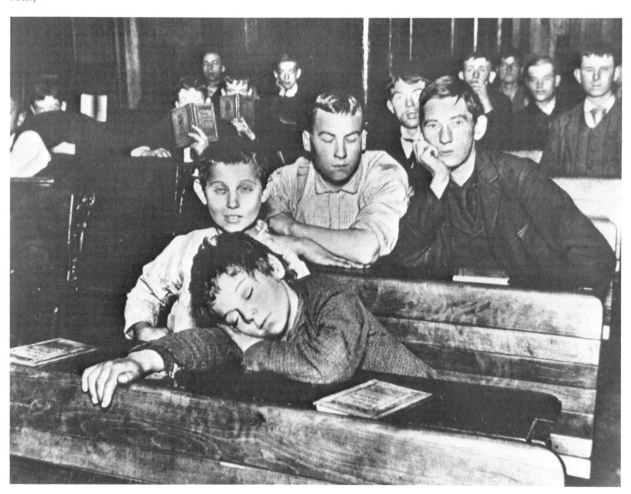

York Tribune. The city, at that time, was jammed with immigrants, one of the most densely crowded urban areas in the world. Disease, crime, and death rates were high. Riis wrote about these terrible conditions and complained to city health officials but without results. He decided to use a camera and the new invention of flashlight powder to make photographs and show conditions inside slums and tenements. In 1890, his historic book, *How the Other Half Lives,* with photographs that he had made of the misery and squalor on the Lower East Side created a sensation. Theodore Roosevelt was then the New York City police commissioner and began to correct some of the worst abuses. A reform movement was started that cleared up the degrading housing situations and the political conditions that permitted them to exist.

Another book, *The Battle with the Slum,* was published by Riis in 1902, and he became a lecturer and a leader of movements for social reform. He died in Massachusetts in 1914. Most important, Riis demonstrated the power of crusading documentary photography, and through his efforts the camera improved the lives of many people.

Jacob Riis was not primarily a photographer. The camera for him was a useful instrument. He produced a relatively small body of work, perhaps three hundred pictures. Another crusading, socially oriented photographer, Lewis Wickes Hine, was greatly productive throughout his lifetime. Hine was born in Oshkosh, Wisconsin, in 1874. He went to the University of Chicago and came to New York City in 1901 to teach science at the Ethical Culture School where he began to use the camera as a teaching aid. He started to photograph at the age of thirty-seven and the subjects of his first documentary series were the impoverished immigrants arriving at Ellis Island. This was the beginning of his use of the camera to show the plight of the underprivileged.

Hine became a staff photographer for the National Child Labor Committee and used his camera to demonstrate the evils of child labor. He made pictures in the New England and North Carolina cotton mills, in the coal mines of Pennsylvania, in beet fields and canneries, and on fishing boats. Hine's photographs of enslaved children and the conditions under which they toiled aroused public sentiment against child labor. The chief executive of the National Child Labor Committee, Owen R. Lovejoy, said, "The work Hine did for this reform was more responsible than all other efforts in bringing the need to public attention. The evils were intellectually but not emotionally recognized until his skill, vision, and artistic finesse focused the camera intelligently on these social problems." Hine's pictures of the exploitation of children in factories and their neglect in the poor neighborhoods directly influenced the passage of legislation against child labor and improved public education and family assistance efforts in the major cities of the United States.

Documentary Photography

15. LEWIS HINE:
*Immigrant Family, Ellis Island,
1905.*
(George Eastman House)

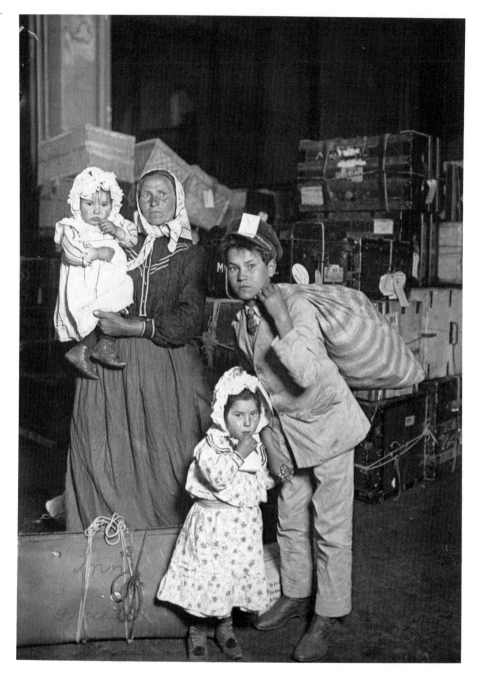

16. LEWIS HINE:
Cotton Mill, North Carolina,
1909.
(George Eastman House)

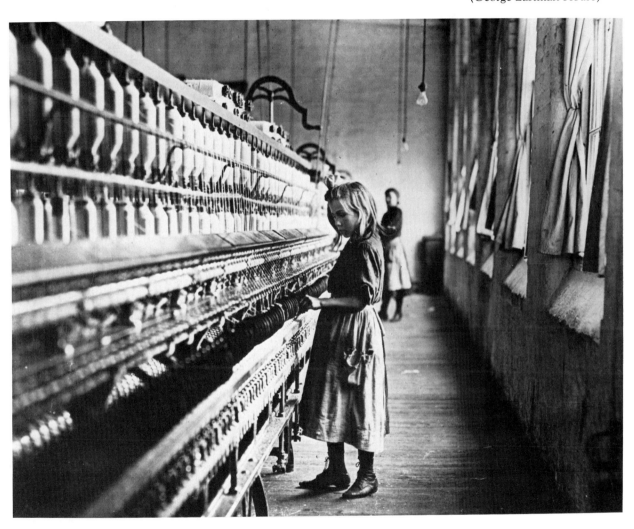

Although Hine is better known for his pictures of the seamy side of life, he devoted most of his efforts to what he called "positive documentation." In his later photographs he expressed an optimistic confidence in the dignity of the worker and an affirmation of industry. For Hine, the American worker was a heroic figure, one who should take great pride in his or her craft. He believed that regardless of gender or station, the worker should not be dwarfed by the process.

At the time of his death in 1940, Lewis Hine had become the most eminent social documentary photographer of his time. He had demonstrated a profound belief in the power of the photograph to educate and its ability to make people realize the values of life. His aims were simple, direct, and clear. Hine said, "I wanted to show the things that had to be corrected; I wanted to show the things that had to be appreciated."

"Organic Realism": Paul Strand

One of Lewis Hine's students at the Ethical Culture School was Paul Strand who himself inspired and influenced many other photographers with his humanistic philosophy and his meticulous working methods. Born in New York City in 1890, Strand, while still a student, was introduced by Hine to the famous gallery of Alfred Stieglitz at 291 Fifth Avenue. After graduation in 1909, Strand joined the Camera Club of New York where he experimented with various techniques and learned much from the club's large library. He brought his prints to Stieglitz for criticism, and the master was so impressed with Strand's approach to photography, his people in the streets, New York traffic, and form and rhythm in common objects that he gave the young photographer a one-man show. Stieglitz also featured Strand's work in the last issue of his magazine, *Camera Work*, a leading publication that presented the new and modern in the visual arts. The photographs were praised as being "brutally direct" and launched Strand's long career at the age of twenty-five.

During World War I, Strand was an x-ray technician in the army and afterward tried advertising and commercial photography. In 1921 he collaborated with Charles Sheeler on a short film and became a movie cameraman. He was one of the cinematographers on Pare Lorentz's classic documentary film, *The Plow that Broke the Plains*. After World War II, Strand returned to still photography and lived in Europe where he was able to live independently on an inheritance from his father. He photographed in France, Italy, the Hebrides, Egypt, Morocco, Ghana, and Roumania. He was assisted by his third wife, Hazel Kingsbury, who was also a photographer. Several books resulted as well as a major retrospective exhibition at the Philadelphia Museum in 1971. Paul Strand died in Orgeval, France, in 1976.

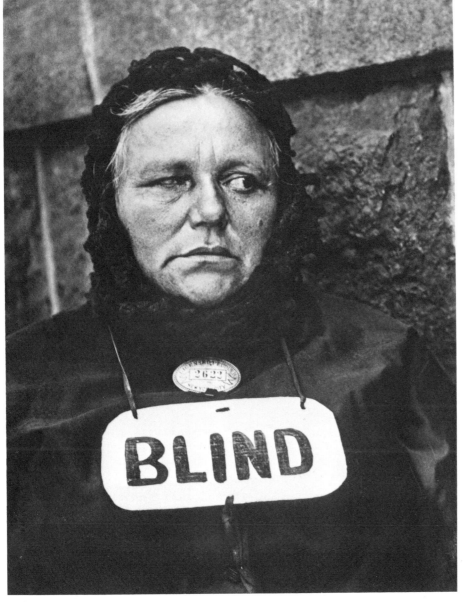

17. Paul Strand:
Blind Woman, New York,
1916.
(Rothstein Collection)

The influence of Strand was enormous. Walker Evans was inspired by the photograph, *Blind Woman*, a closeup of a New York City newspaper dealer at the corner of Lexington Avenue and Thirty-fourth Street. When Evans saw the platinum print now at the Museum of Art, he said that it changed his whole development. Strand was a strong supporter of the Photo League, a group of documentary photographers in New York City. Always the intellectual, he loved to advise young photographers and spoke eloquently of his attitudes and philosophies. In 1916 Alfred Stieglitz said about Paul Strand, "His vision is potential. His work is pure. It does not rely on tricks of process. In the history of photography there are but few photographers who, from the point of view of expression, have really done work of any importance. And by importance we mean work that has some relatively lasting quality, that element that gives all art itself real significance."

Paul Strand made the definitive break from the soft focus romanticism of the nineteenth century and created a new way of seeing with the camera. This new way was a search for the truth of life in the faces, dress, and movement of people, in such artifacts as machines, houses, and churches, and in unadorned nature. He evolved an articulate point of view for his social realism; a point of view which he called "organic realism" that became his personal style and that he adapted to a wide variety of subjects.

Strand said, "We conceive of realism as dynamic, as truth which sees and understands a changing world and in turn is capable of changing it in the interests of peace, human progress and the eradication of human misery and cruelty and toward the unity of all people." He had an artistic belief by which he lived his life. He said:

> A photographer must develop and maintain a real respect for the thing in front of him, expressed through a range of almost infinite tonal values which lie beyond the skill of the human hand. The fullest realization of this is accomplished without tricks of process of manipulation, through the use of straight photographic methods. It is in the organization of their objectivity that the photographer's point of view toward life enters in, and where a formal conception born of the emotions, the intellect, or of both is as inevitably necessary for him before an exposure is made as for the painter before he puts brush to canvas. Photography is only a new road from a different direction, but moving toward the common goal which is life.

The Third Effect: Frances Benjamin Johnston

Neglected by many historians and critics, the pioneering woman photographer Frances Benjamin Johnston is now achieving recognition as a docu-

The Concerned Humanists

18. PAUL STRAND:
White Fence, Park Kent, New York, 1916.
(Witkin Gallery)

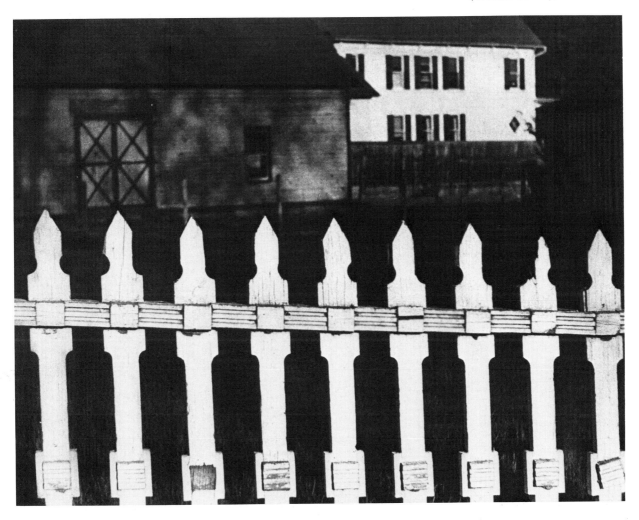

Documentary Photography

19. FRANCES BENJAMIN
JOHNSTON:
*Building a Stairway, Hampton
Institute, Virginia, 1899.*
(Library of Congress)

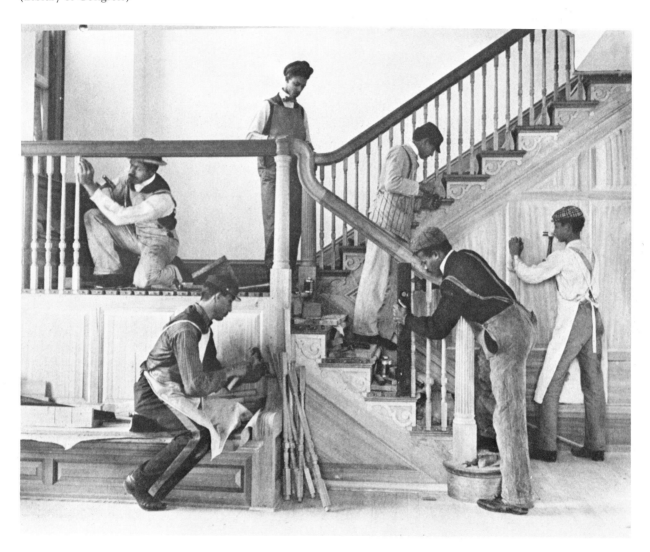

The Concerned Humanists

20. FRANCES BENJAMIN
JOHNSTON:
*Football Team, Hampton
Institute, Virginia, 1900.*
(Library of Congress)

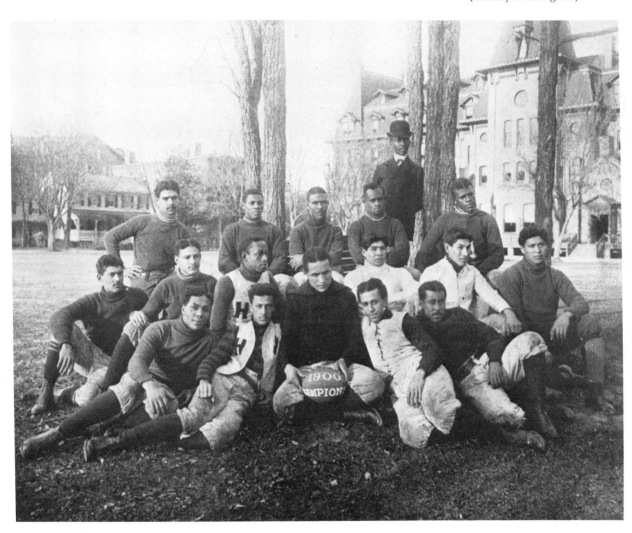

mentary photographer. She was born in Grafton, West Virginia, in 1864, and after a convent school education, went to Paris to study drawing and painting. Then she decided to become a photographer. Upon her return to Washington, D.C., she worked as an apprentice in the photography department of the Smithsonian Institution.

In 1890, after writing to George Eastman in Rochester for advice on equipment, Frances Johnston opened a studio at 1322 V Street, N.W., in Washington, D.C. She was an immediate success, and because of her social position she had access to the White House during the administrations of Cleveland, Harrison, McKinley, Theodore Roosevelt, and Taft. She was particularly close to the Roosevelt family. In the *Ladies' Home Journal* of February 1900, she illustrated an article written by Jacob Riis, the noted documentary photographer, entitled, "President Roosevelt's Children." The presidents, their wives, and members of the cabinet came to her studio for portraits.

Frances Benjamin Johnston was a strong, determined, talented woman who was proud of her accomplishments as a woman and an artist. She considered herself on equal terms with male photographers and demanded and received the same fees for her work as her male contemporaries.

Johnston was interested in architecture. Her documentary photographs, now in the Library of Congress, provide an invaluable record of Colonial and Federal architecture, as well as the mansions built for the Astors, Vanderbilts, and others with their interiors designed by Elsie de Wolfe.

From portraiture and architectural work, she moved on to the photography of social conditions. Frances Johnston toured the Pennsylvania coal fields, descending mine shafts, and entering deep and dangerous tunnels. She photographed the schools of Washington, D.C., Annapolis, West Point, the College for American Indians at Carlisle, and Tuskegee Institute.

Her most famous documentary photographs were made at the Hampton Institute in Virginia in December 1899. This school was designed to provide young blacks and Indians with vocational education. A famous graduate was Booker T. Washington who founded the Tuskegee Institute. Hampton was thirty-one years old when Johnston made her pictures. Today it is a fully accredited liberal arts college.

Frances Benjamin Johnston's photographs at Hampton were made for exhibition at the Paris Exposition of 1900. She wanted to show the devotion of the students and faculty to their work and training. It demonstrated a unique social and educational triumph for America. The original platinum prints now in the Museum of Modern Art in New York City were bound into a presentation album.

In preparing this volume, Johnston may have been the first photographer

to use what has become known as "the third effect." This results from the juxtaposition of two contrasting images of the same subject to create a new meaning. For example, on one page there was a photograph of a black couple in a primitive log cabin with a fireplace, eating at a crude wooden table. On the facing page was a photograph of a well-dressed, prosperous-looking Hampton graduate and his family eating in a dining room with a white tablecloth, napkins, fine furniture, panelled walls, and a painting of the Rocky Mountains.

Frances Benjamin Johnston had the ability to make statements about the real world with her selection of the details in a photograph. She also encouraged other women to become photographers and arranged for exhibitions of their work. One of her illustrated articles was titled, "What a Woman Can Do with a Camera." She had a busy, productive, and long life and died in 1952 at the age of eighty-eight in New Orleans.

For the humanist documentary photographers, the camera was a supreme method for recording what words could only feebly describe. As Jacob Riis said, "The power of fact is the mightiest lever of this or any day."

21. ARTHUR ROTHSTEIN:
*Dust Storm, Cimarron
County, Oklahoma, 1936.*
(Library of Congress)

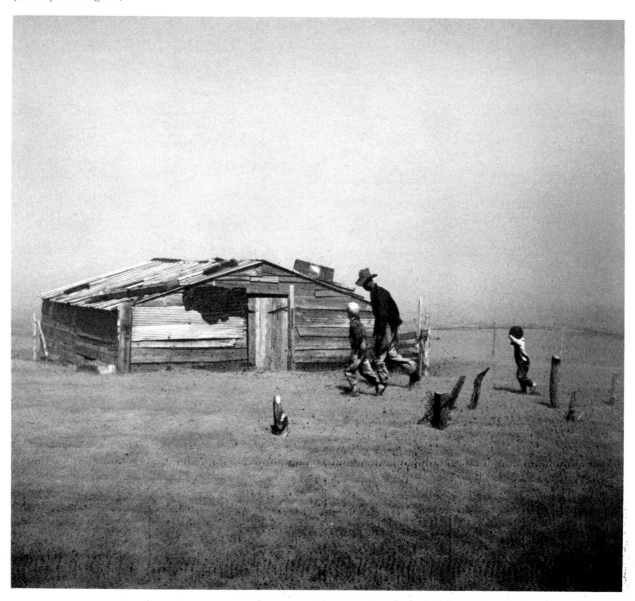

The Farm Security Administration

THE TRADITION OF USING PHOTOGRAPHS to show reality with a point of view dates back to the beginning of photography. However, it was during the Great Depression of the 1930s that the documentary photograph demonstrated its power to inform and influence a nation. This resulted from the formation of a government agency, the Resettlement Administration, in 1935. Under the direction of Roy Emerson Stryker, who was not a photographer, a small group of dedicated men and women used their cameras to show the problems of rural life to the rest of the country. These documentary photographs had a profound effect on legislation and are preserved in the Library of Congress as a national treasure.

Photographs That Move Men's Minds

The purpose of documentary photography is to learn about life—how people live, work, and play; their social structures and institutions; their environment. Pictures are made and collected, preserved and studied so that present and future generations can understand the past. Many documentary photographs are also made for immediate use, not for historical purposes. The aim is to move people to action, to change or prevent a situation because it may be wrong or damaging, or to support or encourage one because it is beneficial. Sometimes this type of documentary coverage is mistaken for propaganda. The definition of propaganda is the spreading of ideas, information, facts, or allegations, deliberately, to help or injure a cause, a person, or an institution. The propagandist tries to be convincing, not objective. The propagandist may distort, select, omit, and arrange material so that the information is presented in a biased manner.

In contrast, a documentary reporter becomes convincing by being truthful. The photographer transmits to the viewer a sense of involvement and concern. If a selection is made, it is done in a balanced way to prevent misinterpretation of the truth. The techniques used are straightforward, without artificial manipulation. Those who look at the documentary photograph are moved to action because they identify with the photographer's eyewitness concern for the subject.

In discussing documentary photography, the writer James Agee said:

> In every other art which draws directly on the actual world, the actual is transformed by the artist's intelligence into a new and different kind of reality; aesthetic reality. In the kind of photography we are talking about here the actual is not at all transformed; it is reflected and recorded within the limits of the camera, with all possible accuracy. The artist's task is not to alter the world as the eye sees it into a world of aesthetic reality, but to perceive the aesthetic reality within the actual world and to make an undisturbed and faithful record of the instant in which this movement of creativeness achieves its most expressive crystallization. Through his eye and through his instrument, the artist has, thus, a leverage upon the materials of existence which is unique, opening to him a universe which has never before been so directly or so purely available to artists and requiring of his creative intelligence and of his skill perceptions and disciplines no less deep than those required in any other act of aesthetic creation, though very differently derived and enriched.

It was James Agee who collaborated with photographer Walker Evans to produce the book *Let Us Now Praise Famous Men,* a milestone in documentary writing and photography. Evans was working for the United States Resettlement Administration in Washington, D.C. In 1936, he requested a leave of absence to work with James Agee on a project for *Fortune Magazine* about the life of a white tenant family in the South. They settled in Hale County, Alabama, lived with, studied, and photographed three families. The results are an excellent example of what happens when a skilled photographer is permitted to concentrate on one subject, using his own judgment, for a length of time.

The FSA Photographers

The program of the historical unit of the Resettlement Administration, which started in July 1935 and lasted seven years, was the largest coordinated effort in social documentary photography. In 1937, the name of the agency

was changed to that of the United States Farm Security Administration (FSA). Unlike the Works Projects Administration (WPA), this government agency was not a makework or relief project. It made a serious attempt to remedy the problems of the sharecropper, the tenant farmer, the migrants fleeing the Great Plains states ravaged by dust storms and drought, and the economic problems of the small farmer.

Under the direction of Roy Stryker, a small group of photographers made the historical record of this New Deal agency in photographs. Stryker, a former instructor in economics at Columbia University, knew Lewis Hine and through his work learned to appreciate the value of the documentary approach. Stryker had a strong social conscience, and although not a photographer, he believed that photographs had the power to move men's minds.

When the project ended because of the move toward war in 1942, 272,000 photographs were on file in the Library of Congress. They represent a priceless collection of documentary photographs that have been used by students, researchers, editors, and historians.

The man who directed and inspired the photographers who created the FSA collection was Roy Emerson Stryker. He was born in Great Bend, Kansas, in 1893. He grew up in Montrose, Colorado, served in the infantry in World War I and graduated from Columbia University in 1921. Stryker remained there as an instructor in economics, working closely with Professor Rexford Guy Tugwell. One of their joint projects was a textbook, *An American Economic Life,* which was heavily illustrated with photographs. During this period, Stryker became acquainted with Lewis Hine whose photographs made a strong impression on him. When Tugwell, a member of Franklin Delano Roosevelt's brain trust, became assistant secretary of agriculture, he invited Stryker to work for the government. With typical disregard for bureaucratic regulations, Roy Stryker assembled a staff of photographers and proceeded to document conditions throughout the country, which at the time was in a deep economic depression. As the director of the project, Stryker learned from his photographers and they helped him devise its approach. This resulted in a combined creative effort that was unique in photography.

Roy Stryker, a teacher with a love for the land, had an inquiring mind and a strong, iconoclastic character. His integrity and energetic dedication helped maintain high technical and aesthetic standards. Stryker insisted that, before photographing a subject, a photographer should know as much about it as possible. He assigned long lists of books to be read. He also prepared suggestions for possible pictures which he called "shooting scripts." These were meant as guides and reminders, not to be followed literally. An example of one of Stryker's shooting scripts is given in Appendix A.

Carl Mydans was speaking for many photographers when he said, "No one ever worked for him for any length of time without carrying some of Roy Stryker with him. In all the years since I left him, when making pictures, I often hear him say, 'Now what are you doing that for? Why are you making that picture?' I still feel I have to justify myself before him as I did when I worked for him."

When World War II brought an end to the FSA photography project, Stryker worked for Standard Oil of New Jersey, the University of Pittsburgh, and the Jones and Laughlin Steel Company. He continued to discover and encourage young photographers.

Roy Stryker's enduring monument is not only the creation of the priceless FSA file of photographs. It is also the change that he and his photographers made in the appreciation of the realistic, documentary image as a vital, significant expression of photographic art.

An exhibition of FSA photographs held in New York City at the First International Photographic Exposition in 1938, produced a strong positive reaction from the public, as well as praise from influential photographers, such as Paul Strand and Edward Steichen.

The first photographer to be hired by Stryker was a former student of his, Arthur Rothstein, who spent the formative years of his five-decade career working as a government photographer for the FSA. The experience was instrumental in shaping his professional philosophy and outlook. "The photography I do now is a direct outgrowth of the documentary photography I did then," says Rothstein. "I learned to be an eyewitness to events and to report in a sensitive and intelligent way the relationships of people to their environments."

Rothstein was hired to be the first photographer immediately after he graduated from Columbia University in 1935. He was paid $1,620 a year and given an allowance of 2¢ a mile and $5 a day for food and lodging. Eventually, there were eleven FSA photographers, among them Dorothea Lange and Walker Evans. "It was our job to document the problems of the Depression so that we could justify the New Deal legislation that was designed to alleviate them," says Rothstein.

When he was hired, Rothstein spent a few months in Washington, D.C., setting up the darkroom and taking photographs in that city, but soon he was sent to the Blue Ridge Mountains of Virginia. That area had recently been designated as the site of the Shenandoah National Park and residents were being moved—"relocated." The people Rothstein was to photograph had inhabited the area for generations, living in log cabins and marrying among themselves. They had intermarried to such an extent that Rothstein found

only two family names among all the people in the area: Corbin and Nicholson.

Rothstein spent a week simply living among and talking with the quaint and shy mountain people so that they could grow accustomed to him before he began to take pictures. He used an unobtrusive 35mm Leica camera that had only recently appeared in the United States. "It was small, inconspicuous and easy to carry around," says Rothstein. "I took the photographs with the camera held in my hand—I didn't use a tripod."

After working in the Blue Ridge Mountains, Rothstein went to Alabama and Mississippi to photograph tenant farmers and sharecroppers. Then he traveled to the ravaged dust bowl region of Oklahoma. It was in Cimarron County, Oklahoma, an area badly damaged by wind erosion, that Rothstein took what is perhaps his most famous picture, and perhaps the most widely reproduced image of the twentieth century, *Dust Storm, Cimarron County, Oklahoma, 1936.* Many families in the area had left the devastated land to migrate to California. But a few families—such as the one in the photograph—had chosen to remain. Arthur Rothstein tells how he came to take that picture:

> I photographed Arthur Coble and his sons Milton and Darrel as they did chores, but the vicious winds made it difficult to see and breathe. As dust began to fill the air, I headed for my car and the Cobles started walking to the farmhouse. When I got in my car, I wanted to wave good-by. I turned and saw the family fighting the wind and took this photograph—the last frame on the roll of film.

The dust storm picture convinced Washington to send government aid to the eroded and drought-stricken Great Plains. Rothstein was able to see the results of that aid in 1978 when he returned to Oklahoma and photographed Darrel Coble—the youngest boy in the earlier picture, now a middle-aged man—and *his* two sons walking through fields of waist-high wheat on the family farm.

Rothstein spent the rest of his five years with the FSA criss-crossing the country taking memorable pictures—among them, *Bleached Skull, Badlands, South Dakota, 1936.* He traveled in a 1936 Ford packed with tripods, flashbulbs, view cameras, food, and water. "I had a sleeping bag in the car," he says, "and an ax to chop down trees that got in the way. The back roads weren't like those we have today. I had a shovel to dig myself out of snow or mud, a water bag, and a Coleman stove to cook things on. I was pretty self-sufficient."

Looking back, Rothstein says that this was a romantic, though sometimes

22. ARTHUR ROTHSTEIN:
*Skull, Badlands, South
Dakota, 1936.*
(Library of Congress)

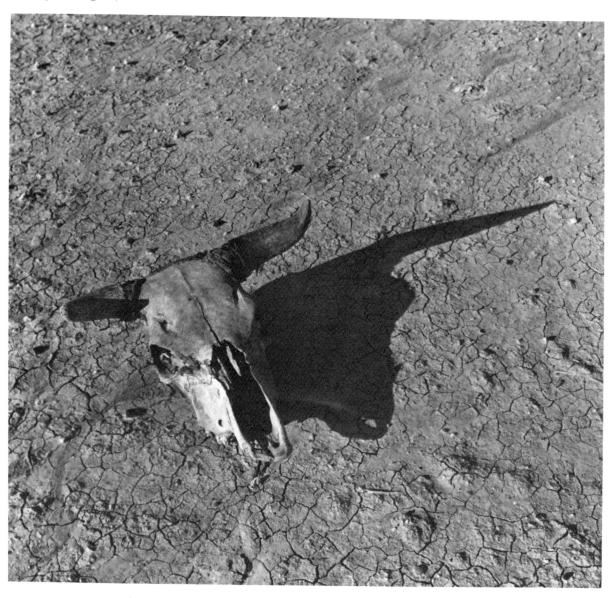

lonely, life for a young man, but was also an education, for he had grown up in New York City and hadn't traveled much. He thinks this lack of experience is one reason his early photographs were so successful. "I approached things with fresh eyes and a certain naiveté," he says.

In 1937, Rothstein took another one of his famous photographs, and his favorite, entitled, *Artelia Bendolph, Gee's Bend, Alabama, 1937.* In the photograph, a young black girl is looking out a cabin window. Although the cabin is crude, Rothstein says that the girl's dignity makes her look "like a queen on the Nile." Next to the girl, on the outside of the cabin, is posted a newspaper advertisement with a picture of a white, well-fed, middle-class woman holding a platter of food. The caption says, "Your Baker Offers You a Tempting Variety!" "What makes this a special picture is that it combines graphic symbols—such as the advertisement—with other elements in the photograph to create a third effect," Rothstein says. "You see the girl—that's effect one. You see the ad—that's effect number two. But the third effect is when you see both images together and recognize the irony."

Although the FSA was established to document the need for various New Deal programs, the photographs were in fact some of the most significant documentary photos ever taken of rural and small-town America and included many scenes that had nothing to do with government programs, such as parties and square dances. By the time Rothstein left the FSA in 1940, he had taken 80,000 photographs, all of which now belong to the government.

Rothstein firmly believes in the value of a photographic record of American life and says he'd be pleased if such a project were undertaken today. "The FSA compiled a priceless record of life in the United States and it is considered a valuable national resource," he says. "I feel that should be done on a continuing basis by the government so that the people of future generations can see what life was like."

Although Rothstein was the first photographer to be hired by Stryker, it was Walker Evans who influenced the FSA style. Evans's approach was one of frank, honest reality, often characterized by a direct, frontal view. This resulted in a geometric pattern and carefully planned elements on the ground glass of his 8-×-10-inch camera. Although this approach had been used by other photographers such as Atget, Strand, and Sheeler, Evans used it not only to create works of art but also to produce meaningful, factual communications.

The painter and muralist, Ben Shahn, contributed both photographs and ideas. He was very political and had strong social views. He made photographs with a 35mm camera in order to have visual notes for his paintings. His photographs are selections of the significant, powerful fragments of the whole

Documentary Photography

23. ARTHUR ROTHSTEIN:
*Artelia Bendolph, Gee's Bend,
Alabama, 1937.*
(Library of Congress)

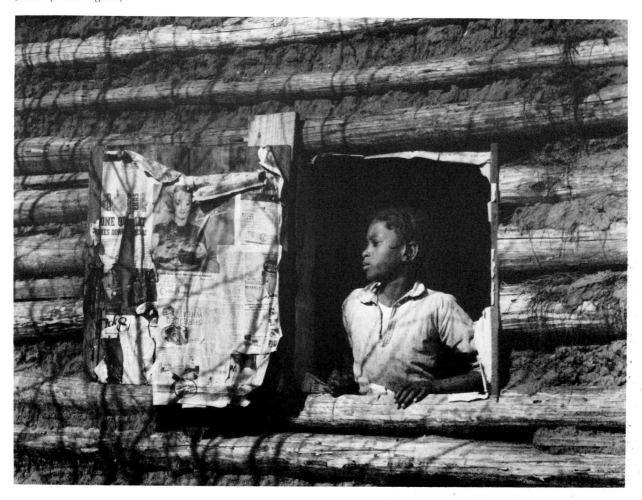

scene which make even more effective statements because of the perception of his artist's eye.

From the very beginning, it was evident that the FSA photographers, who also included John Vachon, Russell Lee, Marion Post Wolcott, Jack Delano, John Collier, Jr., and Carl Mydans, had accomplished their mission to inform the public about rural conditions and obtain support for remedial measures. However, the FSA photographs played an important part also in promoting the recognition of photography as a respected and mature art form. It became apparent, too, that the art of FSA photography was based not in the medium, but in the intention and the conscious plan of the creative worker. The FSA collection also influenced the social commentators and literary figures of the time. Finally, it had a great effect on the emerging practice of photojournalism and visual communication.

In the *New York Times*, the photography critic Gene Thornton said:

It is one of the oddities of our times that photographs like these are still not considered an important part of art history. The standard histories of American art from the ashcan school to abstraction concentrate on painting and are more likely to notice the museum and gallery photography of Stieglitz and his successors than the documentary photography of the FSA photographers and their successors among the photojournalists. I will hazard a guess, however, that in one hundred years, or perhaps even fifty, the documentary photography of Arthur Rothstein and his colleagues will seem far more important as art than all the American painting of the past fifty years.

The photographer who helped set the style of simplicity and directness in FSA photography was Walker Evans. He conveyed a cold sharp realism and, although his photographs seemed austere, they expressed the general through the specific.

Evans was born in St. Louis, Missouri, in 1903. He came from a wealthy family and his parents were divorced. He attended Philips Academy and Williams College.

While trying to find a niche in photography, he shared an apartment with Ben Shahn in Greenwich Village in New York City. The photographs that first brought him recognition were those of Victorian houses in Boston. He also made photographs for Carlton Beal's book, *The Crime of Cuba.* But it was the eighteen months that he was with the FSA that resulted in an extraordinary body of work that has continued to influence photographers. Evans received a Guggenheim Fellowship in 1940 and worked for *Fortune Magazine* as a writer-photographer. During this period, he produced many important

Documentary Photography

24. WALKER EVANS:
Sharecropper's Family,
Alabama, 1936.
(Library of Congress)

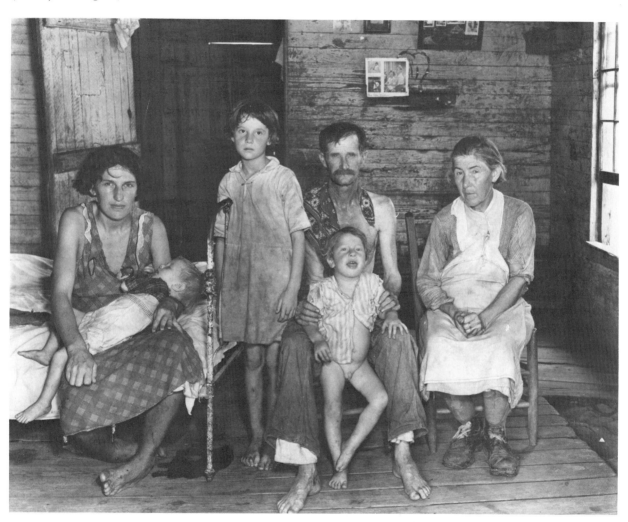

25. BEN SHAHN:
*Sunday Morning, Linworth,
Ohio, 1935.*
(Library of Congress)

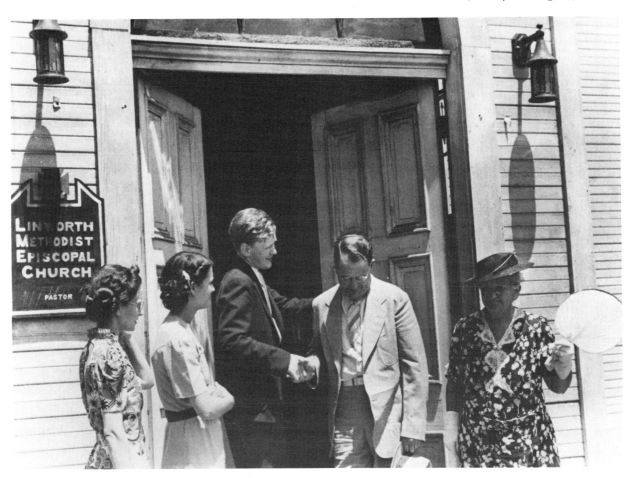

Documentary Photography

26. DOROTHEA LANGE:
Migrant Mother, Nipomo,
California, 1936.
(Library of Congress)

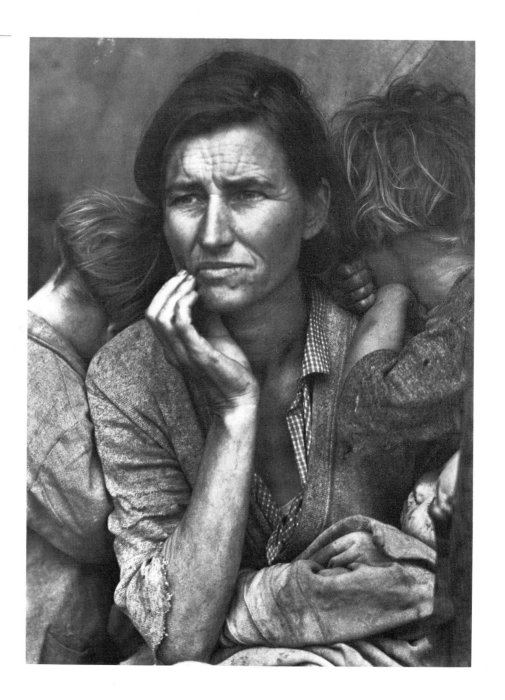

photo essays. At the time of his death in 1975, Walker Evans was professor emeritus of graphic arts at Yale University's School of Art and Architecture.

Evans had strong opinions about photographers. He admired Paul Strand, but disliked Stieglitz, who he thought was "too arty," and Steichen, who he believed was "too commercial." However, Evans was strongly influenced by Ben Shahn and Ben Shahn, in turn, learned from Evans.

Shahn was born in Lithuania in 1898. He came to New York City and studied at the Art Students' League. A lithographer, painter, muralist, and photographer, he worked for the FSA from 1935 to 1938. Thereafter, he practiced commercial illustration and continued painting, using photographs as detailed notes for his compositions. Shahn lived and worked in Roosevelt, New Jersey, a former FSA project, until his death in 1969.

Another photographer, Dorothea Lange, had a different style. Her photographs probed deeply, with sincere emotion and sympathy, into her subjects so that a feeling of compassion was evoked. Her use of the reflex camera made it possible to capture the fleeting expression that had the greatest meaning.

One of the great pictures in the FSA collection is *Migrant Mother, Nipomo, California,* made by Lange in March 1936. Roy Stryker said, "When Dorothea took that picture, that was the ultimate. She never surpassed it. To me, it was the picture of Farm Security. The others were marvelous but that was special." Lange's account of how she made that picture is revealing: "I saw and approached the hungry and desperate mother as if drawn by a magnet. I do not remember how I explained my presence or my camera but I do remember she asked me no questions. I made five exposures, working closer and closer from the same direction. I did not ask her name or her history. She told me her age, that she was thirty-two. She said that they had been living on vegetables from the surrounding fields and birds that the children killed. She had just sold the tires from her car to buy food. There she sat in that lean-to tent with her children huddled around her, and she thought that my pictures might help her and so she helped me." It was Dorothea Lange who brought a humanist, social concern to the FSA group. Her pictures communicate an emotional realism that conveyed individual strength, character, and dignity in the face of hardship.

Lange was born in Hoboken, New Jersey, in 1895, as Dorothea Nutzhorn, but she chose to use her mother's maiden name, Lange. She was a small, strong woman who walked with a slight limp resulting from polio. Dorothea Lange started out to be a teacher, but became interested in photography after studying with Clarence White at Columbia University. She went to San Francisco and worked for Arnold Genthe, and later opened her own studio. In the thirties, Dorothea worked on many projects with Paul Taylor, a professor

Documentary Photography

27. RUSSELL LEE:
*Cattlemen at Auction, San
Angelo, Texas, 1940.*
(Library of Congress)

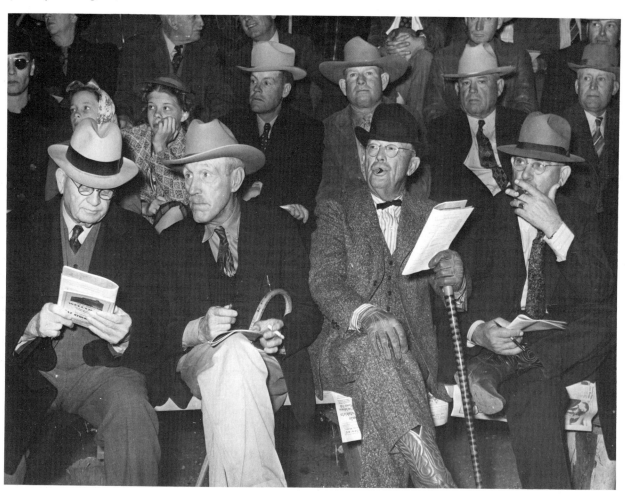

28. JOHN VACHON:
Omaha, Nebraska, 1938.
(Library of Congress)

29. MARION POST WOLCOTT:
Main Street after Blizzard,
Woodstock, Vermont, 1940.
(Library of Congress)

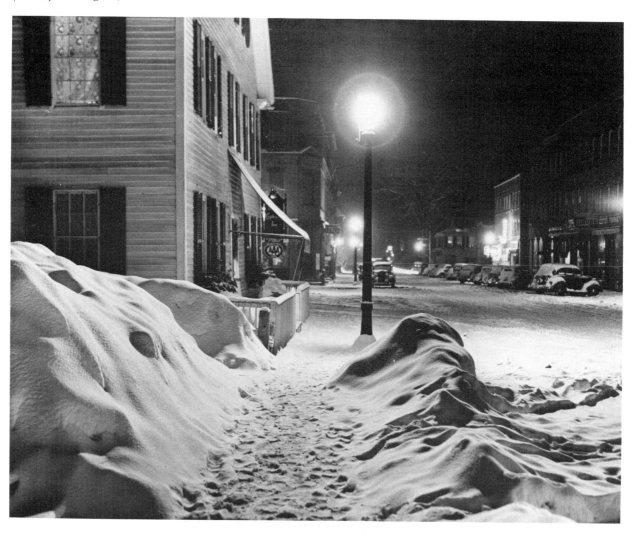

30. JACK DELANO:
*Sharecropper's Home, Greene
County, Georgia, 1941.*
(Library of Congress)

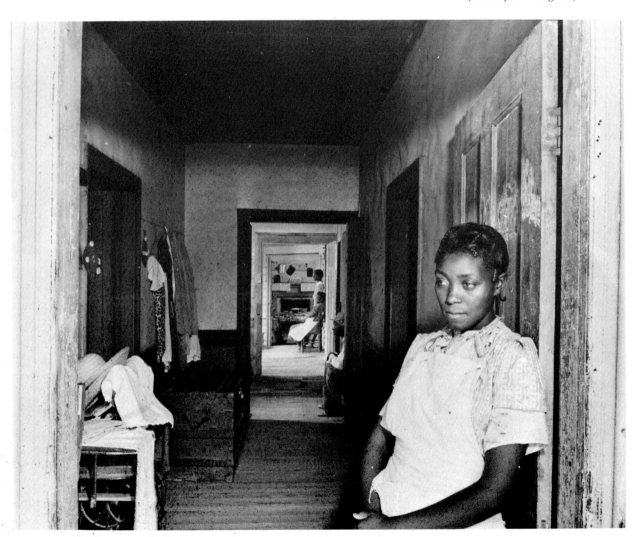

at the University of California at Berkeley, whom she later married. Her photographs of migrant labor brought her to the attention of Stryker who employed her on the FSA project. During World War II, she photographed the Japanese relocation camps in California. In postwar times, she produced many photo essays for *Look* and *Life*. She died in 1965.

One of the most prolific of the FSA photographers was Russell Lee. He was born in Ottawa, Illinois, in 1903, and attended Culver Military Academy and Lehigh University where he obtained a degree in chemical engineering. However, he was attracted to painting and studied with John Sloan at the Art Students' League in New York City. In 1931, he lived for five years in the art colony of Woodstock, New York, gradually drifting more into photography. Lee was an early user of the 35mm camera. He met Ben Shahn who told him about Stryker's project and Lee then applied for a job. He was hired after Carl Mydans resigned to become one of *Life's* first staff photographers.

Lee developed a special approach to documentary photography. It was objective, precise, technically perfect. While some photographers might try to define a subject in one picture, Lee would take an encyclopedic view, building up the visual information through hundreds of selected images.

After the FSA, Lee performed aerial and ground photography for the Air Transport Command during World War II. He worked again for Stryker at the Standard Oil Company of New Jersey and did industrial and magazine photography. Lee retired to Austin, Texas, where he taught and influenced many young photographers at the University of Texas.

When Carl Mydans started working with Roy Stryker, he was already a trained journalist. He graduated from the School of Journalism at Boston University in 1930 and became a reporter for a small financial daily, *The American Banker*. During this time, he bought a 35mm Contax camera and began doing free-lance photography, selling pictures to *Time*.

Through a *Time* editor, Dan Longwell, who later helped create *Life*, Mydans found a job as a photographer in Washington. He was later assigned to Stryker's historical section. Mydans made a great contribution with his trained reporter's eye and his dynamic approach to people. When *Life* started publishing in late 1936, Carl Mydans joined the staff and had a distinguished long career with the Time-Life organization.

John Vachon was born in Saint Paul, Minnesota, in 1914. He received a B.A. from Saint Thomas College there and came to work in Stryker's office in Washington as a messenger and file clerk. In 1940, he was appointed a junior photographer. Vachon also worked with Stryker at the Standard Oil Company of New Jersey. He was a photographer for *Life* magazine and later a staff photographer for *Look* magazine for twenty-three years. He died in 1975.

Vachon was strongly influenced by Walker Evans but later developed his own style, and his pictures of the Great Plains showed a stark and realistic beauty.

Marion Post Wolcott was born in 1910 in Montclair, New Jersey. Her mother was a political activist involved with birth control and social work. Marion attended the New School, New York University, and the University of Vienna in Austria. Returning to New York City, she studied photography with Ralph Steiner, who brought her portfolio to the attention of Roy Stryker. In addition, on June 20, 1938, Roy Stryker received a letter from Paul Strand:

> It gives me pleasure to give this note of introduction to Marion Post because I know her work well. She is a young photographer of considerable experience who has made a number of very good photographs on social scenes in the South and elsewhere. I feel that if you have any place for a conscientious and talented photographer, you will do well to give her an opportunity.

Marion Post worked for the FSA until 1941. She married Lee Wolcott who worked for the U.S. Foreign Service, raised a family, and lived on a farm in Virginia, and later moved to New Mexico. She traveled with her husband to Iran, Pakistan, Egypt, and India. After his retirement from the Foreign Service, they moved to Santa Barbara, California.

Marion Post brought a pictorial sense of composition to her photographs that reflected the reality of life. She pictured the rich as well as the poor. Her photographs of Miami Beach were especially revealing. Marion Post appreciated the good earth but was also aware of the defects in the soil and its people. Her contribution was to balance the FSA file with refreshing candor and perception.

Jack Delano was born in Kiev, Russia, in 1914. He came to the United States as a boy and studied music and art in Philadelphia. From 1937 to 1939, he was a photographer with the WPA, and in 1940, he started working for Roy Stryker. During World War II, he was a photographer with the Air Transport Command. Delano settled in Puerto Rico in 1946 where he has lived and worked in photography, television, and music. In 1983, he completed a "rephotography" documentary project in Puerto Rico. Delano went to many of the places where he had made pictures 40 years before and photographed them again.

How to Obtain FSA Prints

The FSA photographs were widely used during the thirties and forties. They were published in newspapers, magazines, and books. Many were syndicated nationally by the Associated Press, United Press, and International

News Photos. The early issues of *Life* and *Look* contained many FSA photographs. This extensive distribution and publication resulted from several factors. The subject matter of the photographs was different and unusual. Few news photographers covered the events portrayed. The quality of the photography was at a high standard both technically and aesthetically. The pictures were readily available, in a well-maintained file, with captioned 8-×-10-inch glossy prints provided free to researchers and editors. This was because the photographs were in the public domain, having been made by salaried civil service photographers. The FSA photographs are still widely used in books, magazines, films, and television, without restriction. Prints are available for a nominal fee through the U.S. Library of Congress, Prints and Photographs Division, Washington, D.C. 20540.

Curiosity and Objectivity

DOCUMENTARY PHOTOGRAPHERS all have a common characteristic. They are curious, yet objective. They search with inquisitive zeal for the essence of nature and events. They examine and scrutinize in order to reveal the truth.

The Childlike Curiosity of André Kertész

The aesthetic style of a photograph is often a mirror of the artist's personality. Some documentary workers are cold, objective, and austere. Others are warm, witty, and exuberant. One of the most influential and admired photographers of the twentieth century, André Kertész, made photographs with a childlike curiosity of every phase of human activity.

Kertész has an unquestioned acceptance of life and an ability to record with perception and sensitivity that which charms and stimulates him. Without a specific cause, Kertész makes photographs that teach tolerance, respect, and love.

André Kertész was born in Budapest in 1894, the son of a rich Hungarian banking family. After graduating from the Academy of Commerce, he found a job in the Budapest Stock Exchange. Using his first savings to buy a small hand-held camera that used 4- × -6-cm plates, he became committed to photography and gave up the world of finance.

While serving in the Austro-Hungarian Army in World War I, Kertész created a remarkable visual diary of his homeland. He was also shot near the heart but recovered completely to lead a long, creative life. In 1925, Kertész moved to Paris, to start a career in photojournalism. He soon became a member of the artistic community, exhibiting his innovative work and having his pictures published in European magazines. More than any other photographer, he influenced the way in which European photography developed.

In Paris, Kertész was admired, successful, and prosperous. In 1936, Ker-

Documentary Photography

31. ANDRÉ KERTÉSZ:
The Kiss, Budapest, 1915.
(Rothstein Collection)

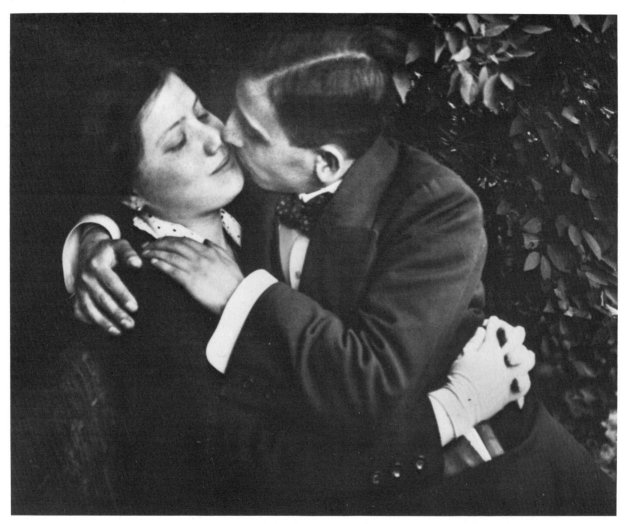

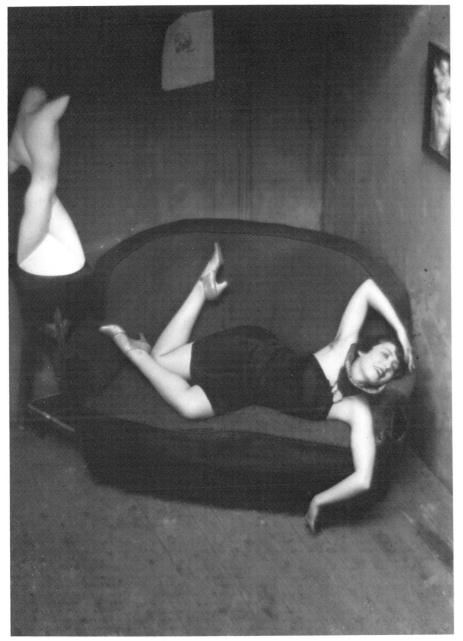

32. André Kertész:
Satiric Dancer, Paris, 1926.
(Rothstein Collection)

tész came to New York to work for a commercial studio, but because of the approach of war, he found it impossible to return to Europe. For the next twenty-five years, Kertész was a commercial photographer for the Conde Nast publications. He found it difficult to adjust to the editorial attitudes of American magazines and he concentrated on interiors and still-life studies.

However, he continued, in his free time, to photograph in his personal, unpredictable manner. He chose odd compositions and angles, searched for the unfamiliar look of that which is ordinary, patterns of windows, arrows of traffic direction, photographs of tenderness and amusement.

In 1964, the Museum of Modern Art in New York City gave him long-deserved recognition with a one-man show. At that time, the director of the Museum's Department of Photography, John Szarkowski, said, "These most recent pictures seem in their freshness to be the work of a greatly gifted beginner discovering for the first time the beauty of photography but, in their economy and ease, in their abandonment to the uncomplicated pleasure of seeing, they are the work of a master. The photographic world has begun to realize again that in much of what it values, it is the heir of André Kertész."

The Eye of Paris: Brassai

In Paris, André Kertész had a friend who was a painter, sculptor, and fellow Hungarian. Born in 1899, his real name was Gyula Halasz, but when he settled in Paris in 1924, he changed it to Brassai, meaning "from Brassov," his native village. Brassai borrowed a camera from Kertész in order to record life in Paris at night. He was immediately delighted with the possibilities of photography, and for several years he prowled the streets of Paris after dark.

In 1933, the publication of his book, *Paris de Nuit*, created a sensation. Brassai had documented the underworld of Montparnasse with its prostitutes, homosexuals, hoodlums, its strange and depraved habitués of seedy bars and cafes.

He received assignments from magazines and lived in France, working for the American publication, *Harper's Bazaar*, until 1965. Although his photographs had a realistic, candid quality, Brassai worked with technical precision to create his simple glossy prints. He said, "I invent nothing, I imagine everything." Another revealing comment of his was, "The creative moment lies in the selection of the subject." Brassai had a profound understanding of people and their environment. He appreciated the incongruous, the ridiculous, and the prosaic. He was called "the eye of Paris."

An art critic of the *New York Times*, reviewing an exhibition of Brassai's photographs of Paris, wrote, "The great photographer of this lost world was Brassai who inhabited it with an unmistakable relish and yet observed it with

33. BRASSAI:
Madame Bijou in the Bar de la Lune, Montmartre, Paris, 1932.
(Witkin Gallery)

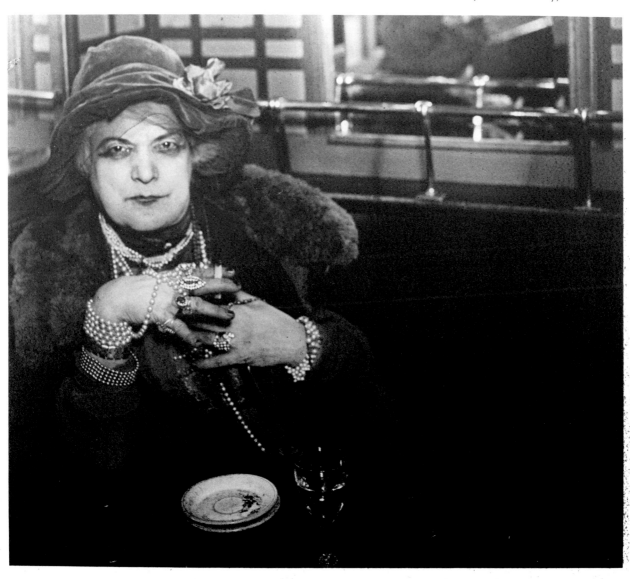

Documentary Photography

34. BRASSAÏ:
*In a Bar, Place Pigalle, Paris,
1932.*
(Witkin Gallery)

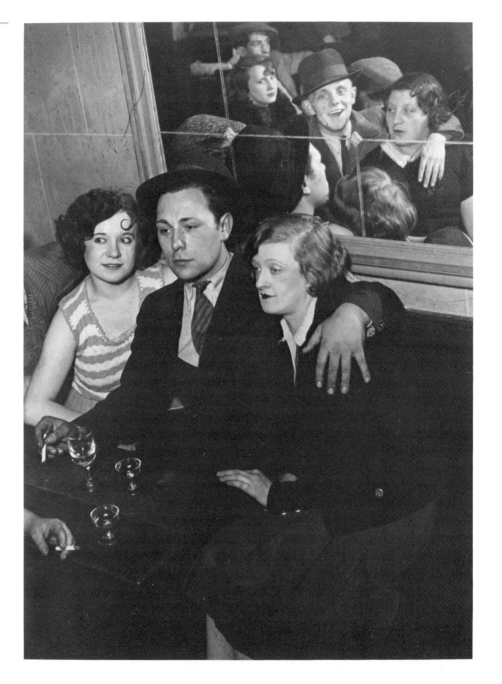

that special combination of detachment, excitement and empathy we feel in an artist who has discovered his true metier." At the age of eighty-four, Brassai, one of the major European photographers of this century, died at his home on the Côte d'Azure, near Nice.

The Naked City: *Weegee*

By coincidence, a photographer also born in 1899, made photographs of the dark side of New York City. This was "Weegee," whose pictures of night life in the 1930s on the Bowery and the city's crime, murders, and fires seemed to mirror the work of Brassai on the other side of the Atlantic. Weegee was born Arthur Fellig and emigrated with his family from Poland to the United States when he was ten years old. Like millions of others, he was processed through Ellis Island in New York City. He left school at the age of twelve for a variety of jobs. He was a dishwasher, sold candy in burlesque houses, and made tintypes as a street photographer with a pony named Hypo.

When he was twenty-four, Fellig was hired to work in the laboratory of Acme News Pictures on the night shift. He slept on a shelf in the darkroom. He became a stunt man developer, developing film on the subway as it moved from the Battery to Midtown. Or he processed pictures of a baseball game in a rented ambulance speeding from the Polo Grounds to the Acme office. In 1935, Fellig became a free-lance photographer. With his 4-×-5-inch Speed Graphic, flash attached, always ready, he photographed accidents and crime scenes. He listened to the police radio broadcasts and often arrived at the location before the police did. He sold his pictures at five dollars a print. The police, baffled by his ability to know exactly where to go, began to call him "Weegee" after the popular fortune teller's "ouija board." An eccentric with no close relations, Weegee was both inconsistently shy and raucous. He was a cigar-smoking slob, but he empathized with the poor, the ugly, and the lonely. Underneath his gruff exterior was the warm, human tenderness of a man who had a difficult time as a child. He was a survivor.

One of his most famous photographs was *The Critic,* made in 1943 at the opening of the Metropolitan Opera season. It showed the arrival of Mrs. George Washington Cavanaugh and Lady Peel, both wearing tiaras, ermine capes, and heavy jewelry. At the right, a thin, scraggly woman is hissing at them. Weegee said, "I could smell the smugness so I aimed the camera and made the shot."

In 1945, Weegee published a book of his photographs titled *The Naked City.* He sold the title to a movie company in Hollywood and then went to the film capital where he acted in character parts as a fight manager, a bum, and a derelict. In 1956, he began living with Wilma Wilcox, a Quaker and a social

35. WEEGEE:
*The Critic. Mrs. Leonora
Warner and her mother, Mrs.
George Washington
Cavanaugh, attending the
opening of the Metropolitan
Opera, New York, 1943.*
(International Center of
Photography)

36. DIANE ARBUS:
*Patriotic Parades, New York,
1967.*
(International Center of
Photography)

worker from Iowa. She was a tall, rural type as well as a charming, orderly executive who helped to organize his later life until his death in 1968.

The Tragic Diane Arbus

Another generation has admired the documentary photographs of Diane Arbus who made her pictures in the style of Weegee and Brassai but without their compassion. Arbus photographed freaks, waifs, transvestites, nudists, identical twins, and aging stripteasers. She took her camera into places where others have not been, and she made some devastating pictures. As Weegee did, she was able to find the mean smugness in the middle class and to expose their vulgarity. She was attracted to the psychologically and physically deformed. Her pictures were personal statements, and she said, "The subject of the picture is more important than the picture."

Although Diane Arbus seemed to disdain aesthetics, her sense of composition and scale gave her photographs great impact. However, it often seemed that these images, so vivid and graphic, were a reflection of her own personal psychological problems. She had a short career. Born in 1923, she committed suicide in 1971. Looking at her pictures it is hard to realize that Diane Nemerov Arbus was the daughter of a wealthy New York merchant family. She attended the Ethical Culture and Fieldston schools and studied photography at the New School.

In 1941, she married a professional photographer, Allan Arbus, and they worked together in his studio. Allan and Diane Arbus were divorced in 1961. Diane worked for many magazines. *Esquire* gave her an assignment to photograph New York City. This started her on a self-assigned program for making photographs of the oddities of the human species for which she developed a merciless talent. She said, "A photograph is a secret about a secret. The more it tells you, the less you know." Diane Arbus tried to document those aspects of society that many people overlook and in the process she revealed much of her own tortured personality.

In her book, *On Photography*, Susan Sontag says, "An ugly or grotesque subject may be moving because it has been dignified by the attention of the photographer." She also writes, "To photograph people is to violate them, by seeing them as they never see themselves, by having knowledge of them they can never have." However, documentary photography may also be a reflection of the society in which we live. At first, it was the goal of the documentary photographer to show what was wrong with the world and to move people to action so that these wrongs could be corrected. Later, the photographer looked at the world even more objectively. There was no attempt to make a judgment, only to present a view of reality. The message became less important to a clear, cold view with a type of subject matter that is more provocative than pleasurable.

Politics and Realism

A GROUP OF DOCUMENTARY PHOTOGRAPHERS called the Photo League worked in New York City from 1936 to 1951. During that period, many prominent photographers supported the League, and its members produced an important body of work. Although political in origin, the Photo League consisted of a group of talented, dedicated photographers who worked hard to establish standards and to help others. Among those active in the Photo League were Aaron Siskind, Sid Grossman, Lou Stoumen, Jack Manning, Walter Rosenblum, Helen Levitt, Morris Engel, Sol Libsohn, and Lewis Hine. After Hine's death, Grossman and Libsohn rescued his prints and negatives, and the Photo League preserved, published, and exhibited Hine's work. Later, Walter Rosenblum found a home for the valuable collection at the George Eastman House in Rochester, New York.

The New York School

The Photo League has been credited with the establishment of a "New York School" with attitudes and philosophies that were distinct from those in other geographic areas. Certainly, it contributed to the definition of the social documentary approach.

When it was founded, the Photo League declared as its aim,

> Photography has tremendous social value. Upon the photographer rests the responsibility and duty of recording a true image of the world as it is today. Photography has long suffered from the stultifying influence of the pictorialists. The Photo League's task is to put the camera back in the hands of honest photographers who will use it to photograph America.

As examples of "honest photographers," the League listed Eugene Atget, Lewis Hine, Paul Strand, and the FSA photographers. According to one

Documentary Photography

37. AARON SISKIND:
*Dancers at the Savoy
Ballroom, Harlem Document,
New York City, 1937.*
(© Aaron Siskind)

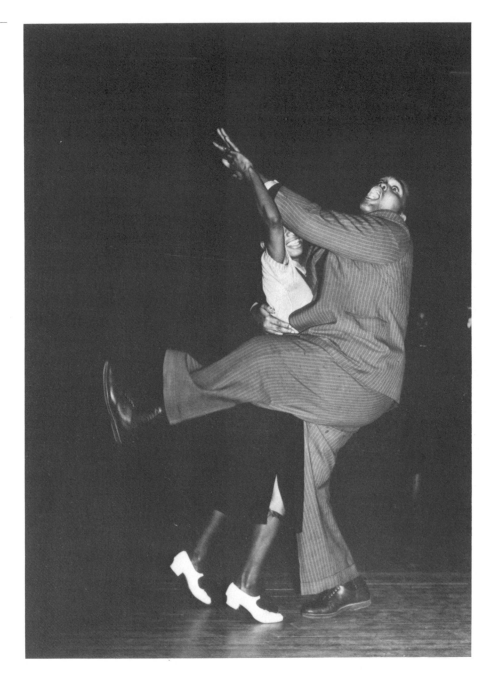

member, it was "an application of photography, direct and realistic, dedicated to the profound and sober chronicling of the external world."

The Photo League was originally called the Film and Photo League, and it started operating in 1930 as a cultural activity of the left-wing Workers' International Relief group. Its object was to oppose and expose reactionary films, to produce documentary films reflecting the lives and struggles of the American worker, and to spread and popularize the great artistic and revolutionary Soviet productions. This early heritage of sympathy with Communist causes and organizations gave the Photo League its vitality and led to its problems many years later.

In 1936, the filmmakers broke away from the still photographers, and the Photo League began to operate as a volunteer membership group of both amateurs and professionals. They maintained a loft near Union Square, published a newsletter, *Photo Notes*, sponsored lectures and discussions, conducted a school, produced documentary portfolios, and preserved the work of Lewis Hine as a memorial.

The Photo League was open every evening and on weekends. One member, Morris Engel, called it "a refuge, a home. It filled a gap in my emotional life. I entered and pleasure came." But the League was more than a camera club. Its organizers, Sid Grossman, Sol Libsohn, and Walter Rosenblum, urged its members to search for a deeper understanding of documentary photography—a union of technical photographic excellence with an aesthetic and critical examination of the subject. They hoped to develop a sensitivity on the part of their members so that they could photograph society without compromise.

The membership and school fees were low and for many aspiring young photographers, the Photo League afforded an opportunity that was not available elsewhere. Every noted photographer who came to New York was invited to lecture. No fee was paid and no one refused. The members heard Lewis Hine, Roy Stryker, Berenice Abbott, Ansel Adams, Edward Weston, Dorothea Lange, Paul Strand, and many others of equal stature.

The Photo League's *Photo Notes* was a mimeographed newsletter that Edward Weston described as "the best photo magazine in America today." Some of its contributors were Beaumont Newhall, Paul Strand, John Vachon, and Eliot Elisofon. One of the members, Helen Levitt, was born in New York City in 1918. She studied with Walker Evans and was inspired by him and James Agee. Her photographs are straightforward, dynamic, and lyrical views of life in the New York City streets. She has captured the fleeting gestures and the unexpected reactions of children when playing their games and acting out their fantasies.

Documentary Photography

38. JACK MANNING:
*Peace Meals, Harlem
Document, New York City,
1937.*
(© Jack Manning)

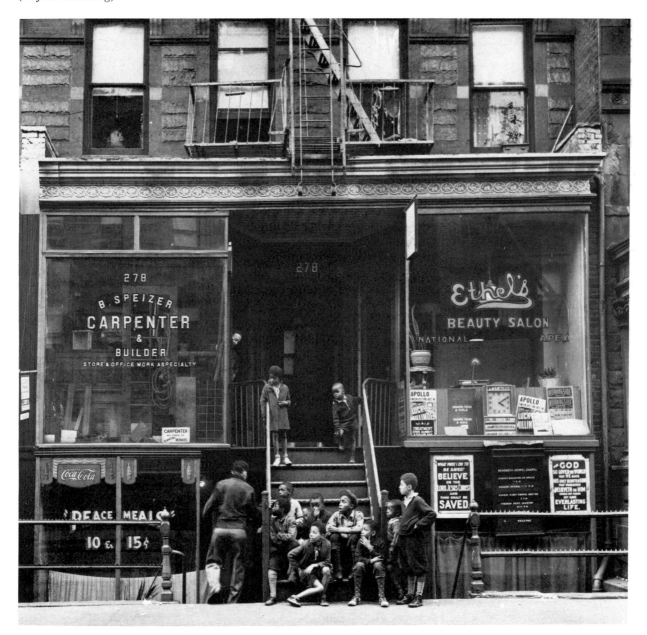

39. MORRIS ENGEL:
*Harlem Merchant, New York
City, 1937.*
(© Morris Engel)

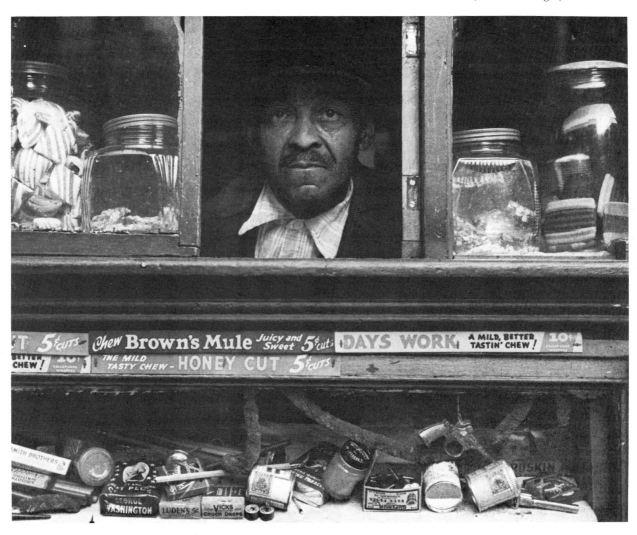

Documentary Photography

40. HELEN LEVITT:
*Cops and Robbers, New York
City, 1940.*
(Museum of Modern Art)

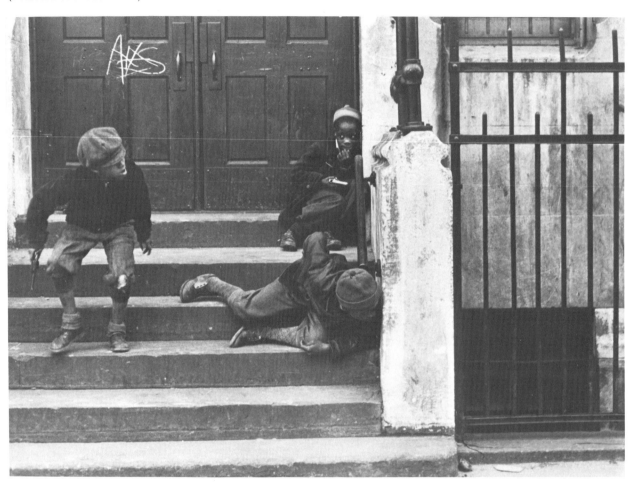

Exhibitions of work by the membership and by invited guest photographers were frequently displayed at the League headquarters. Weegee's first exhibit was at the Photo League. But the Photo League's most important achievement was a body of work that consisted of a series of documentary photographic essays. Among them were Grossman and Libsohn's *Chelsea Document*; Rosenblum's *Pitt Street*; and Aaron Siskind's *Harlem Document.* Other projects included *Park Avenue North and South, Portrait of a Tenement,* and *Dead End: The Bowery.*

Politics and Documentary Photography

During World War II, many of its members were in the armed forces and the League produced photographs for the Red Cross and servicemen's organizations. In 1947, the Photo League estimated that more than fifteen hundred photographers had been trained in its school. It was preparing to move into larger quarters when the membership was dismayed by its appearance on a list of subversive organizations. Although the 103 members denied the allegations made by Attorney General Tom Clark, and they were defended by Paul Strand and other eminent supporters, they could not resist government pressure. It was the time of the cold war, a period of political tension, a time of fear and reaction. Many members resigned and by 1951, the Photo League ceased to exist.

The dominant personality in the Photo League was Sid Grossman who for many years as a teacher and photographer exercised a strong influence. Able and committed, Grossman persuaded Paul Strand to teach at the school and enrolled Ansel Adams and Edward Weston as members. In order to improve his printing skills, Lewis Hine took a course with Grossman.

With the political blacklisting of Communists, Grossman, who freely admitted his membership in the Communist party, retired to Provincetown on Cape Cod where he taught photography privately. His photography moved away from a socially motivated approach to a more personal, visual style emphasizing content and form. There is a collection of Sid Grossman's work in the Museum of Fine Arts in Houston, Texas.

The Photo League influenced many of its members who continued to work and teach as photographers. There was a sense of vitality and purpose that became part of their lives. They, in turn, have influenced another generation in the need to link the reality of content and form in the portrayal of urban life.

Changing New York: Berenice Abbott

One of the most enthusiastic supporters of the Photo League was Berenice Abbott whose ten-year project of photographing the rapidly changing scene in

Documentary Photography

41. WALTER ROSENBLUM:
Hopscotch, East 105th Street,
New York City, 1952.
(Rothstein Collection)

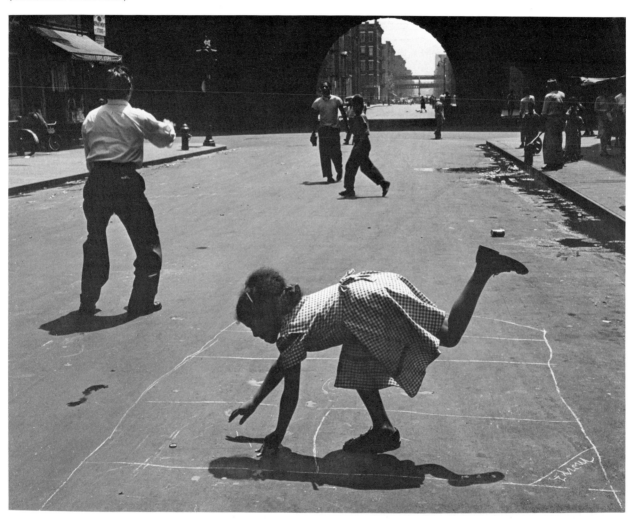

42. Berenice Abbott:
Eugene Atget, Paris, 1927.
(Witkin Gallery)

43. BERENICE ABBOTT:
Night Scene, Manhattan,
1935.
(Witkin Gallery)

44. BERENICE ABBOTT:
*Blossom Restaurant, 103
Bowery, New York City,
1935.*
(George Eastman House)

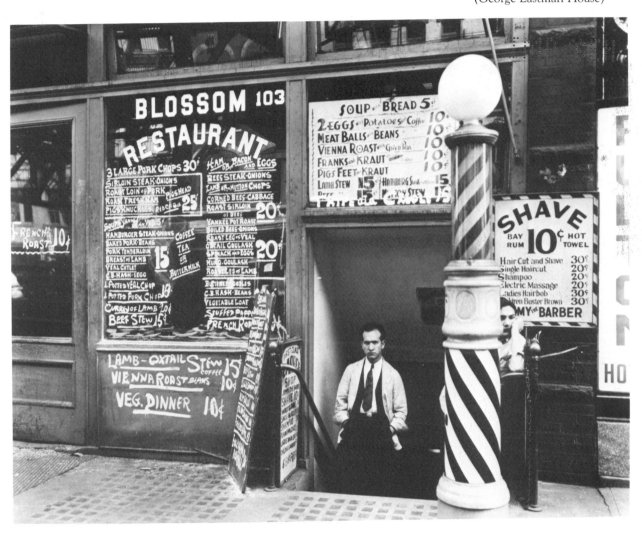

New York City resulted in a collection of documentary photographs that form an extraordinary record of urban construction and creation.

Berenice Abbott was born in Springfield, Ohio, in 1898. After a short period at Ohio State University, she moved to Greenwich Village in New York City and was attracted by the artistic and intellectual activity there. By 1923, Abbott was living in Paris, working as an assistant to Man Ray. She then opened a portrait studio and photographed the leading artists and writers of the period, including James Joyce, André Maurois, André Gide, and Marcel Duchamp. Her portraits show her subjects in all their individuality and idiosyncracy. Miss Abbott said, "Portraits are very interesting to do, but the photographer has to have a flair for it. It is difficult because during the taking there has to be a kind of exchange. I only tried to let people be themselves, you can't pose them."

In Paris, Berenice Abbott became acquainted with Eugene Atget, then unknown, whose documentary photographs have the intensity of great works of art. She rescued and preserved Atget's work, printed his negatives, and made the world aware of his genius. Her own development as an artist was certainly influenced by that experience. About Atget's photography, Abbott wrote, "It has a relentless fidelity to fact, a deep love of the subject for its own sake, a profound feeling for materials, surfaces and textures, a conscious interest in permitting the subject photographed to live by virtue of its own form and life."

Abbott's own photographs reflected that statement. In 1929, she returned to New York City. It was a boom time, neighborhoods were disappearing, skyscrapers were being erected. It was a complex urban area, rapidly changing. For ten years, Berenice Abbott recorded the spirit and aspect of the great metropolis. This was done under the auspices of the Federal Art Project of the Works Progress Administration. The negatives and a master set of prints are now in the Museum of the City of New York. Some of the landmarks that she photographed no longer exist. Others, such as Rockefeller Center, under construction, are still standing. Her work is a valuable resource for urban historians. In 1939, a selection of her photographs was published in the book *Changing New York*.

About this work, Berenice Abbott wrote:

To make the portrait of a city is a life work and no one portrait suffices, because the city is always changing. Everything in the city is properly part of its story—its physical body of brick, stone, steel, glass, wood; its life blood of living, breathing, men and women. Streets, vistas, panoramas, bird's eye views and worm's eye views, the noble and

the shameful, high life and low life, tragedy, comedy, squalor, wealth, the mighty towers of skyscrapers, the ignoble facades of slums, people at work, people at home and people at play.

Berenice Abbott prefers to use the 8-×-10-inch camera. As a result, her photographs are detailed and full of information. She has said:

I believe in realism. I believe in the objective approach. I am very much against pictorial or pretty photography. The lens forming an image is a realistic thing. The lens is real; it is sharp, it is clear. There are very few photographers today that have the guts to be themselves. They follow fads. As long as what you do is honest and expresses something worth expressing, you can do just about anything. Photography is as wide as the eye is wide. There is no limit to our material.

45. HENRY
CARTIER-BRESSON:
*Behind the Gare St. Lazare,
Paris, 1932.*
(Rothstein Collection)

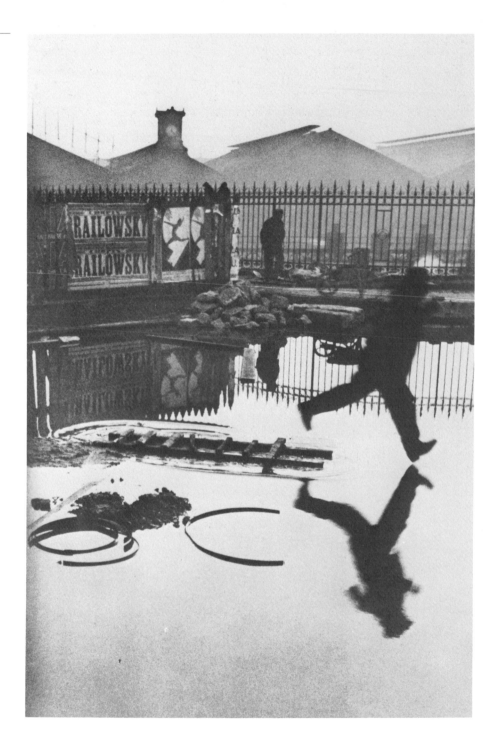

The Eyewitness Observers

THE POWER AND IMPACT of the documentary photograph results from its acceptance as pictorial evidence of the eyewitness photographer. It presents facts, information, and proof emphasized by those inherent characteristics of the medium—sharpness, detail, full gradation of tone, and stopped action.

There are other considerations that distinguish the documentary photograph. One is an appreciation of all the techniques required to maintain the honesty and credibility of the image—composition, focus, lighting, appropriate format, and superb craftsmanship. Another important ingredient is the perception of the photographer, sensitive to the subject. This results also in an observation of the scene and its interpretation of that which is significant.

Photojournalism

All these qualities apply also to photojournalism, which may be defined as the production of pictures for publication. The photojournalist is a documentary photographer who communicates with a large audience by means of the printed page. All photojournalists are therefore documentary photographers, but not all documentary photographers are photojournalists. This is because not all documentary photographers produce their pictures for reproduction in newspapers or magazines.

The epitome of the documentary photographer and photojournalist is Henri Cartier-Bresson. He once said that he preferred to be described as a surrealist, but his friend Robert Capa convinced him that no one would take him seriously so he became a photojournalist.

Henri Cartier-Bresson's photographs have been widely published in mag-

azines and books. He has had many exhibitions, and his work has had a great impact on other photographers. His technique and his photographs are related. Cartier-Bresson was one of the first to understand the remarkable potential of the 35mm camera. Its small size and light weight give the photographer great mobility. Its fast lens permits shooting unobtrusively in available light. Its eye-level viewing makes it an extension of the photographer's own vision. Its rapid operation and 36-exposure film makes quick shooting possible. With this camera, Cartier-Bresson has made vivid, realistic pictures of every aspect of life throughout the world. In his hand, his camera has become an extension of his eye and mind. He has said, "Photography is for me the development of a plastic medium, based on the pleasure of observing and the ability to capture the decisive moment in a constant struggle with time."

When Cartier-Bresson makes pictures he uses the 35mm camera with an effortless, reflex action. He seeks the most revealing camera position rapidly and releases the shutter at the precise moment when the lighting, form, and expression combine to create the best effect. He does not crop the resulting image because that would be "an admission of failure to see in a creative way." There is nothing accidental about his photographs. They are a deliberate arrangement of the essential elements.

Henri Cartier-Bresson was born in Chanteloup, France, in 1908. He studied painting and was influenced by the photographs of Atget and Kertész. He began to take photographs seriously in 1930. During World War II, he was a corporal in a photographic unit. Captured by the Germans, he spent three years in prisoner-of-war camps. After three attempts to escape, he succeeded in 1943 and then worked for the Paris underground. In 1947, Cartier-Bresson became one of the founders of the cooperative picture agency, Magnum, and he proceeded to work on assignments all over the world with his pictures published in hundreds of magazines.

Henri Cartier-Bresson's work and his philosophy about photography has had a strong influence on other photographers. He wrote:

> Manufactured or staged photography does not concern me, and if I make a judgment, it can only be on a psychological or sociological level. There are those who take photographs arranged beforehand and those who go out to discover the image and seize it. For me, the camera is a sketch book, an instrument of intuition and spontaneity, the master of the instant which—in visual terms—questions and decides simultaneously. In order to give a meaning to the world, one has to feel oneself involved in what he frames through the viewfinder. This attitude requires concentration, a discipline of mind, sensitivity, and a

sense of geometry. It is by great economy of means that one arrives at simplicity of expression. One must always take photos with the greatest respect for the subject and for oneself.

As a documentary photographer, Henri Cartier-Bresson captures the scene as an objective observer, always ready to stop time at the moment when the picture is complete.

Winning fame and fortune with her camera, Margaret Bourke-White was a prominent photojournalist who was an expert at the documentary recording of events and social conditions. She was one of the first to appreciate the photogenic qualities of American industry. She was among the early photographers who used the camera for social comment, and as a photographic correspondent, she recorded wars, politics, and news events on a global scale.

She was born in 1904 and was influenced by her parents—her mother who loved nature, wild life, and biological science and her father, an inventor with patents in the field of printing and photography. According to Bourke-White it was her father whose philosophy of life gave her inspiration: "Never leave a job until you have done it to suit yourself and better than anyone else requires you to do it. That, and the love of truth which is requisite number one for a photographer."

Although she studied photography at Columbia University for a short time with Clarence White, it was photographer Ralph Steiner who convinced Bourke-White that a photograph should not resemble a painting. This was in 1926, and Bourke-White said, "I belonged to the soft-focus school in those days; to be artistic, a picture must be blurry."

She graduated from Cornell University in 1927 and opened her first studio in Cleveland, Ohio, specializing in architectural and industrial photography. Two years later, Henry Luce, who had admired her photographs of a steel mill, invited Bourke-White to work for a new magazine, *Fortune.* As Luce described it to her, "In this new publication, words and pictures should be partners. The camera should explore every corner of industry from the steam shovel to the board of directors acting as an interpreter of modern civilization." Bourke-White agreed that this concept would afford her great opportunities in photography. For several years, she produced impressive portfolios of many industries.

Then, Luce decided to produce a new magazine—*Life.* Bourke-White became one of the first staff photographers. She welcomed the prospectus for that magazine, which declared:

To see life; to see the world; to eyewitness great events; to watch the faces of the poor and the gestures of the proud; to see strange things—

Documentary Photography

46. Margaret
Bourke-White:
Convicts' Work Gang, Hood's
Chapel, Georgia, 1937.
(Syracuse University Library)

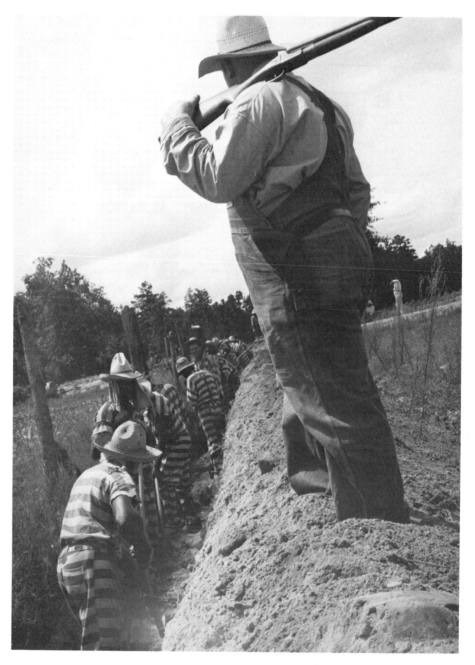

machines, armies, multitudes, shadows in the jungle and on the moon; to see man's work—his paintings, towers and discoveries; to see things thousands of miles away, things hidden behind walls and within rooms, things dangerous to come to; the women that men love and many children; to see and take pleasure in seeing; to see and be amazed; to see and be instructed.

With this manifesto, *Life* ushered in the golden age of photojournalism in 1936. In the pages of *Life, Look,* and other magazines, photographers, writers, and art directors combined their pictures, words, and layouts to create the photo essay—a story told in pictures, organized so that the communication of ideas and emotions became most effective.

Margaret Bourke-White's photograph of Fort Peck Dam in Montana was on the first cover of *Life* and inside the magazine was a photo essay on life in a frontier boom town. The editors of *Life* described these photographs as "human documents."

Bourke-White continued, during her long career, to produce many human documents. She made a memorable survey of the tenant farmers in the South, later published as a book, *You Have Seen Their Faces.* During World War II, she flew on combat missions, covered the invasion of Italy, photographed the air raids over Moscow, and made unforgettable pictures of the survivors of Hitler's death camps at Buchenwald.

After the war, Bourke-White continued to photograph both tirelessly and fearlessly. She covered India as it gained its freedom and had a last session with Gandhi, six hours before he was assassinated. She went down two miles into the South African gold mines to work at temperatures over 100 degrees. She went up eight miles into the stratosphere with the U.S. Strategic Air Command. She was in Korea and Central America and continued her photographic odyssey all over the world to create impressive photographic documentaries until her death from Parkinson's disease in 1971. As a photojournalist and documentary photographer, Margaret Bourke-White has provided a unique chronicle of the life of her times that will remain a treasured record of history.

Photo Essays

A photographer who set high standards for himself and met them time and again has been both an inspiration and a challenge to others in the field. This was the legacy of William Eugene Smith, who produced documentary photo essays that were unsurpassed. Born in Wichita, Kansas, in 1918, Smith was a news photographer at fifteen. After a year at Notre Dame University, he

47. MARGARET
BOURKE-WHITE:
*Mahatma Gandhi at a
Spinning Wheel, Poona, India,
1946.*
(Syracuse University Library)

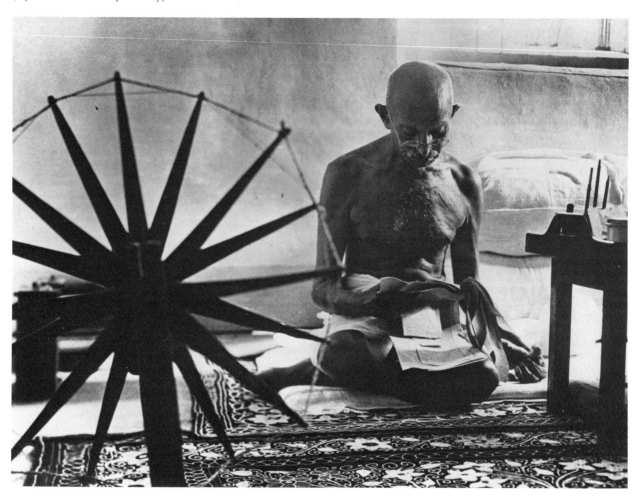

48. W. Eugene Smith:
*Tomoka-chan, Minamata,
Japan, 1972.*
(Witkin Gallery)

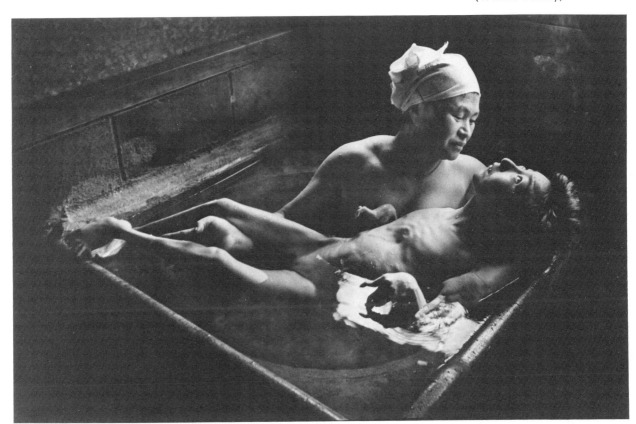

went to New York and worked for a number of magazines. During World War II, Smith photographed as a war correspondent and was severely injured on Okinawa. Also on Okinawa was the war correspondent Ernie Pyle, later killed in the Pacific, who said, "Gene Smith is an idealist, trying to do great good with his work, but it will either break him or kill him." These words, in 1945, were prophetic because that is exactly what happened.

After two years of surgery and hospitalization, Gene Smith made one of his most famous photographs of his two children titled *A Walk to Paradise Garden*. It was the memorable picture in Steichen's famous exhibition, "The Family of Man."

From 1947 to 1954, Smith actively produced masterful photo essays for *Life*. Among all these essays, Smith's favorite was one about a black midwife, Maude Callen, working in a rural district of North Carolina. Smith said, "It was the most rewarding experience photography has allowed me."

Many believe that his best, eloquent photo essay was "The Spanish Village," produced in 1951, a superb blend of words and pictures. The photographs of the remote village of Deleitosa in western Spain with its 2,300 inhabitants living their days in poverty, work, and faith is a classic.

Smith's other picture stories were also produced with equally high values. One of them, about Dr. Albert Schweitzer in Africa, caused Smith to resign from *Life* because he disagreed with the editorial selection, cropping, and layout of his pictures.

He then undertook a major photographic documentary project on the city of Pittsburgh, self-financed and never brought to completion. In 1962, Smith went to Japan where he did some photography for a large industrial firm. Then, in the 1970s, he produced his last major photo essay on the problems of the southern Japanese city of Minamata and the people of the fishing communities on the islands of the Shiranui Sea. These people were victims of environmental poisoning with methyl mercury, a waste product of a chemical factory. Those who were exposed to the pollution suffered from pain, neurological disorders, birth deformities, and death. Smith's publication of this dramatic documentary photographic evidence helped to stop the disregard for the environment and aided the victims in their demands for compensation. Upon his return to the United States, Smith moved to Tucson, Arizona, as photographer in residence at the Center for Creative Photography where he died in 1978.

W. Eugene Smith said about himself:

I am an idealist. I often feel I would like to be an artist in an ivory tower. Yet it is imperative that I speak to people, so I must desert that

ivory tower. To do this, I am a journalist—a photojournalist. But I am always torn between the attitudes of the journalist who is a recorder of facts and the artist who is necessarily at odds with the facts. My principal concern is for honesty, above all, honesty with myself.

It is this legacy of high moral and artistic values that W. Eugene Smith leaves to the many documentary photographers that followed.

Documentary Photography

49. MATHEW B. BRADY:
*General George Armstrong
Custer, 1864.*
(Smithsonian Institution)

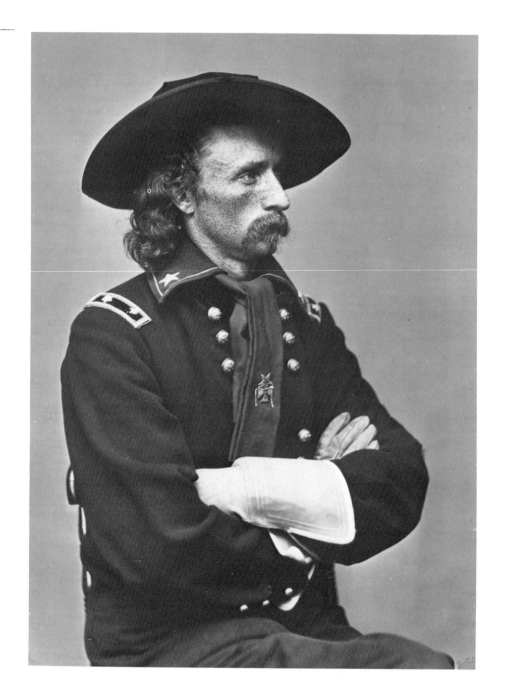

Testament Against War

MANY DOCUMENTARY PHOTOGRAPHERS have covered wars and a few have specialized in that ultimately realistic form of eyewitness recording and interpretation. Some have died in the process of showing the world the agony, distress, and misery of that ever-present social aberration—war.

There are wars taking place somewhere on this planet all the time. From the beginning, those who have photographed combat have produced documentary photographs by the very definition of that art form. These photographs have been unposed, realistic, unmanipulated, and certainly loaded with social comment. They capture that frozen instant, that precise moment when the photographer, sensitive to the action, produces a revealing image.

The Civil War and Mathew Brady

Although the photographs of Mathew Brady during the Civil War in the 1860s were time exposures, they, too, show and record views of documentary significance. Brady used a darkroom on a horse-drawn wagon on the battlefield. The darkroom was a wooden enclosure lined with canvas that completely shut out sunlight when the rear door was closed. The interior provided storage for plates, chemicals, and a large camera and tripod. In the summer, especially in the South, the sun beat relentlessly on this darkroom, turning the inside into a stiflingly hot oven in which not a breath of air stirred. The tinted lanterns that provided a subdued orange light added to the heat.

In order to make photographs, Mathew Brady coated a clean glass plate in this darkroom with a mixture of collodion and silver nitrate to make it light sensitive and put this plate into a light-tight holder. Brady then set up his camera on a tripod on the battlefield and made an exposure of three seconds in

Documentary Photography

50. Mathew B. Brady:
*General Philip Henry Sheridan
and His Staff, Commanding
the Army of the Shenandoah,
1864.*
(Library of Congress)

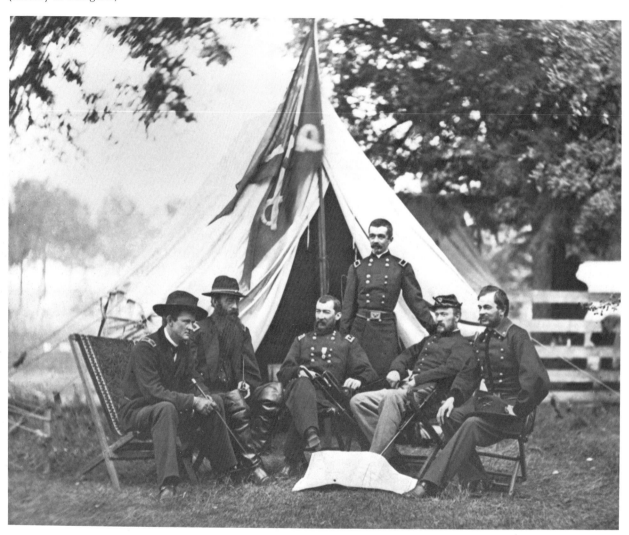

51. U.S. ARMY SIGNAL
CORPS:
*Infantry Attacking, France,
1917.*
(National Archives)

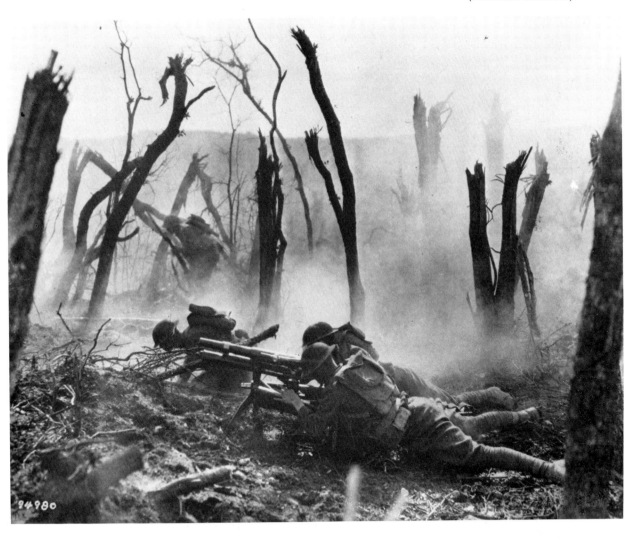

Documentary Photography

52. JOE ROSENTHAL:
Flag Raising on Iwo Jima,
1945.
(Associated Press)

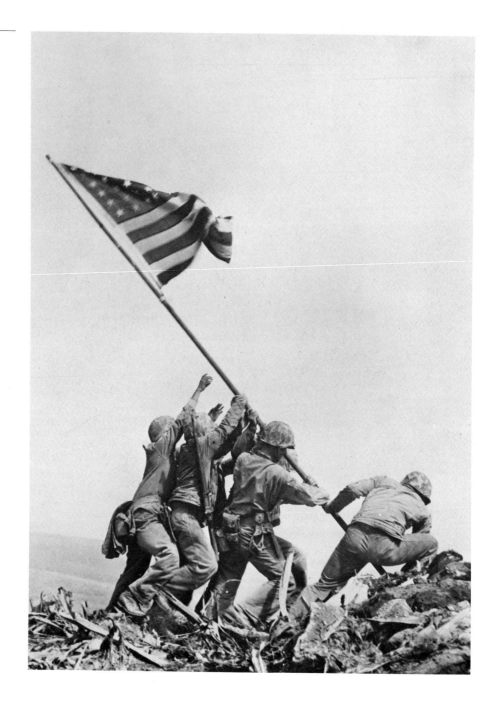

53. ROBERT CAPA:
The International Brigade,
Madrid, Spain, 1936.
(Rothstein Collection)

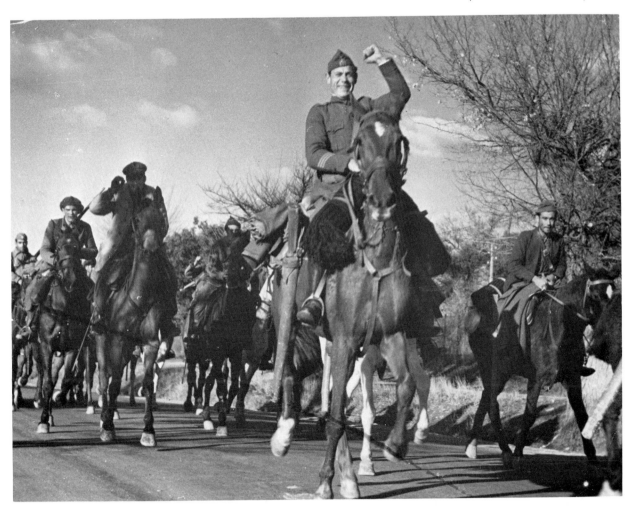

54. Robert Capa:
Death of a Loyalist Soldier,
Spain, 1936.
(Rothstein Collection)

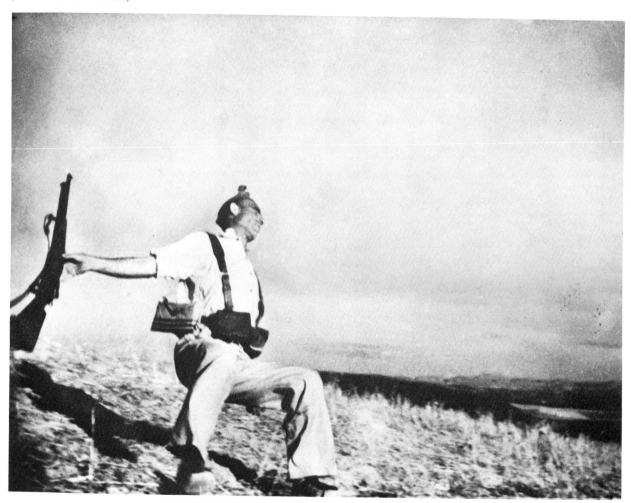

bright sunlight. Brady rushed back to his darkroom on wheels, and before the collodion coating on the plate could dry and the silver nitrate crystallize, he bathed the exposed plate in pyrogallic acid. After the image appeared, he washed the plate in water and then poured a solution of sodium hyposulphate over the developed plate to get rid of any remaining silver salts. After giving the plate a more complete bath in water, he held it near the hot lantern, moving it rapidly in the air to dry. Then, he varnished the plate and the job was done. During all this time, Brady hoped that no cannonballs would come crashing through his darkroom on wheels.

The Bravery of Robert Capa

It was not until after the turn of the century that photographic technology improved so that photographers could show action in combat. It was the combination of the 35mm camera, high aperture lenses, fast emulsion speeds on film, and the daring, reckless bravado of Robert Capa in the Spanish Civil War of 1936 that truly showed the organized violence of man in an effective way.

Robert Capa was born in Budapest, Hungary, in 1913, as Andre Friedmann. At the age of eighteen, he went to Berlin where he became a darkroom assistant and then a photographer for a German photo agency while he studied at Berlin University. With Hitler's rise to power, Friedmann was forced to move to Paris where he invented the name of Robert Capa, "a rich, talented American photographer," in order to sell his pictures. Eventually, he assumed that identity.

His first war assignment in the Spanish Civil War gave Capa international recognition. His picture of a Loyalist soldier, falling at the instant he is killed by machine gun fire has been described as the most dramatic war photograph ever made. The next combat area he covered was China during the Japanese invasion.

During World War II, Capa was at every front, producing photographs that were published in newspapers and magazines around the world. He parachuted with the invasion forces into Sicily and landed with those that invaded Normandy. Capa became the most famous war photographer of his generation. He said, "If your pictures aren't good, you aren't close enough."

After the Second World War, Capa wished to become an "unemployed war photographer." However, he went to Israel in 1948 to record the struggles of that new nation. In 1954, he was photographing French combat troops at Thai Binh in North Vietnam when he was killed by a land mine. Capa photographed five wars in eighteen years. He left a legacy of human valor, his own as well as those he preserved forever in his pictures. Ernest Hemingway

wrote, "He was a good friend and a great and very brave photographer. It is bad luck for everybody that the percentages caught up with him. It is especially bad for Capa. He was so much alive that it is a hard long day to think of him as dead." Robert Capa created a documentary testament against war and it cost him his life. In a memorial tribute, John Steinbeck wrote:

> It does seem to me that Capa has proved beyond all doubt that the camera need not be a cold mechanical device. Like the pen, it is as good as the man who uses it. It can be the extension of mind and heart.
>
> Capa's pictures were made in his brain. The camera only completed them. You can no more mistake his work than you can the canvas of a fine painter. Capa knew what to look for and what to do with it when he found it. He knew, for example, that you cannot photograph war because it is largely an emotion. But he did photograph that emotion by shooting beside it. He could show the horror of a whole people in the face of a child. His camera caught and held emotion.
>
> Capa's work is itself the picture of a great heart and an overwhelming compassion. No one can take his place. No one can take the place of any fine artist, but we are fortunate to have in his pictures the quality of the man.
>
> We have his pictures, a true and vital record of our time—ugly and beautiful, set down by the mind of an artist.

Advice for Combat Photographers from David Douglas Duncan

A combination of daring, artistry, and concern resulted in the production of excellent documentary war photographs by David Douglas Duncan. As a marine in World War II, Duncan was aware of the technicalities of military maneuvers and procedures. His understanding of the military approach made it possible to anticipate the most dramatic events. Duncan was also a superb technician and aware of proper viewpoint and composition.

In his book, *This Is War!*, Duncan describes his method of working.

> The photographs were made with a Leica camera. During assignments, two of these Leicas were carried, one on each side of my body, slung from their leather straps which went around the neck and crossed like ammunition bandoliers in front of my chest. All of my rolls of film were in my back pack, along with a toothbrush, bar of soap, bottle of insect repellent, single blanket, extra pair of socks and a waterproof poncho. Two canteens were always worn hanging from a regular web belt. A spoon was stuck in the breast pocket of the field jacket which was worn, day and night, together with a wrist compass. That was all,

and it was ideal, for it was thus possible to keep moving with the men, without need to return to any of the headquarters.

The reason for two Leicas being used was fundamental—one was fitted with the standard 50mm lens, and the other with a telephoto. By having two focal length lenses always ready, any kind of action could instantly be covered.

Duncan used Japanese Nikkor lenses fitted to his Leica cameras, because he believed that they were superior to any others. It was Duncan and other photographers who covered the war in Korea that made it possible for Japanese cameras and lenses to be accepted and sold in the United States.

As a lieutenant in the U.S. Marines, Duncan carried a carbine and a camera in the Pacific. He fought and photographed alongside the Fiji Islanders who were guerrillas behind the Japanese lines. He flew twenty-eight combat missions over Okinawa. During the signing of the surrender in Tokyo Bay, Duncan was the Marine photographer who recorded that historic event.

Duncan covered riots, revolution, and warfare in Iran, Palestine, India, Egypt, Greece, and Vietnam. His most vivid and memorable photographs were made during the Korean War in 1950. Duncan marched with the Marines of his old outfit, the First Division, in their bitter withdrawal from the border of Communist China to the Korean Sea. He photographed their inexhaustable courage with sympathy and honesty.

Duncan's photographs have become recognized as true pictures of the awfulness of war. The haunted expressions of his soldiers, physically worn out, staring with empty eyes, are memorable. He said:

> I wanted to show what war did to a man. I wanted to show something of the comradeship that binds men together when they are fighting a common peril. I wanted to show the way men live, and die, when they know death is among them, and yet they will find the strength to crawl forward armed only with bayonets to stop the advance of men they have never seen, with whom they have no immediate quarrel, men who will kill them on sight if given first chance. I wanted to show something of the agony, the suffering, the terrible confusion, the heroism which is everyday currency among those men who actually pull the triggers of rifles aimed at other men known as "the enemy." I wanted to tell a story of war, as war has always been for men through the ages. Only their weapons, the terrain, the causes have changed.

David Douglas Duncan, whose alliterated name was beloved by editors, was born in Kansas City, Missouri, in 1916. At college, he boxed in more than

Documentary Photography

55. DAVID DOUGLAS
DUNCAN:
Marines under Fire, Korea,
1950.
(Rothstein Collection)

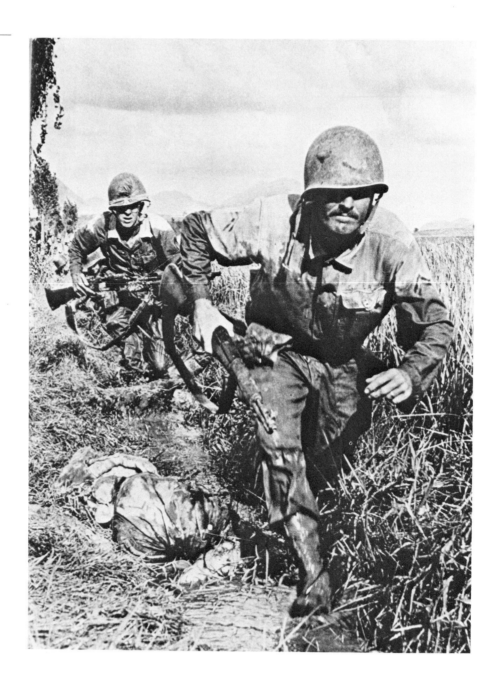

forty bouts, winning most of them. He graduated from the University of Miami and worked as a deep sea diver, airline publicity photographer, and a photographer for fishing and hunting expeditions. It was his commission as a photo officer in the U.S. Marine Corps in 1943 that started his long involvement with war photography.

For those who may find themselves covering a war, Duncan offers the following advice:

1. Keep your head down.
2. Get some understanding of military tactics so you will know what to do to protect yourself.
3. Know your equipment so that you can use it automatically. Use the lightest possible camera and shoot from eye level.
4. Then move in close, close, close and keep the picture simple.

The War in Vietnam

The documentary photographs produced by the courageous men and women who covered the Vietnam War have certainly had the greatest impact. Although thousands of words were written and thousands of feet of film and videotape were exposed during the conflict, it was the classic documentary eyewitness still photograph that influenced public opinion most powerfully and had the greatest effect.

Three pictures were memorable. They were: (1) the suicide by immolation of a Buddhist monk on a Saigon street photographed by Malcolm Browne of the Associated Press in June 1963; (2) the execution of a Vietcong prisoner by a South Vietnam General on a street in Saigon photographed by Eddie Adams of the Associated Press on February 1, 1968; (3) the terrified children on Route 1 in South Vietnam fleeing an aerial napalm attack photographed by Nick Ut of the Associated Press on June 8, 1972.

The Agony and Anguish of Don McCullin

A photographer who has covered the conflicts of the world and returned with grim eyewitness documents of suffering around the world is Donald McCullin. His photographs of misery are strong stuff. He never seemed to flinch from blood and butchery. With his pictures published in magazines and newspapers everywhere, he has without question influenced the thinking of a large audience. Don McCullin was born in the east end of London in 1935. His attitudes toward society were formed as a child of the working class. He won a scholarship to the Hammersmith School of Arts and Crafts, but had to go to work when his father died. He joined the Royal Air Force and was a photographic assistant.

Documentary Photography

56. Malcolm Browne:
*Buddhist Monk's Suicide
Protest, Saigon, 1963.*
(Associated Press)

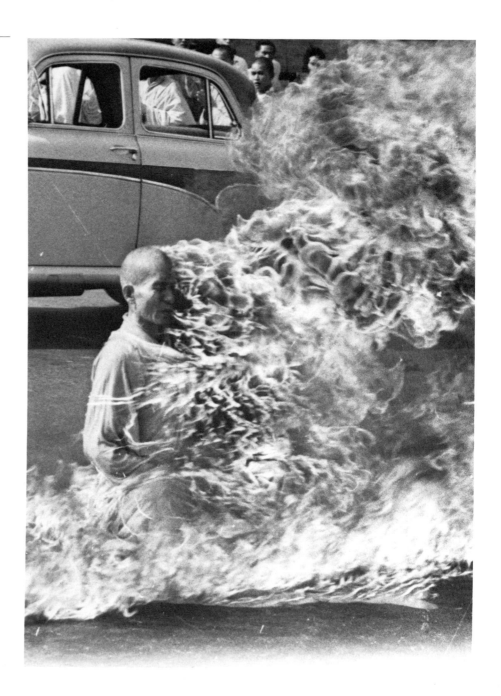

57. Eddie Adams:
Execution in Saigon Street,
1968.
(Associated Press)

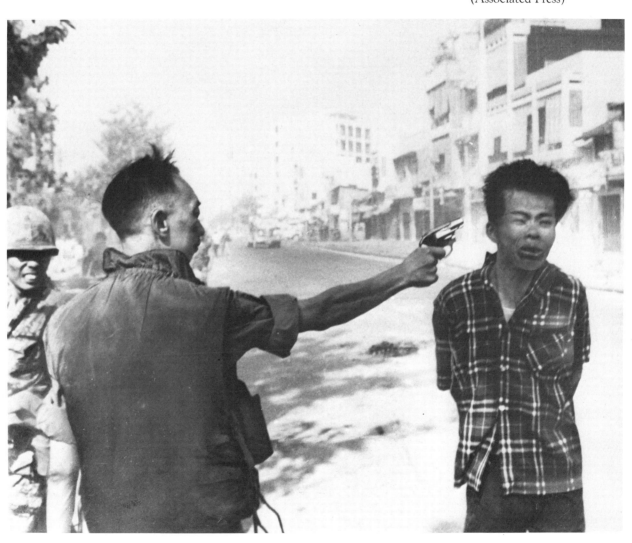

58. NICK UT:
Fleeing Napalm Bomb Attack,
Vietnam, 1972.
(Associated Press)

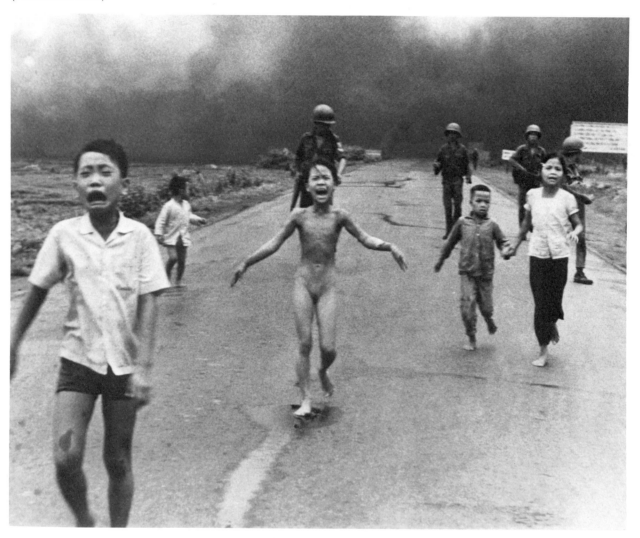

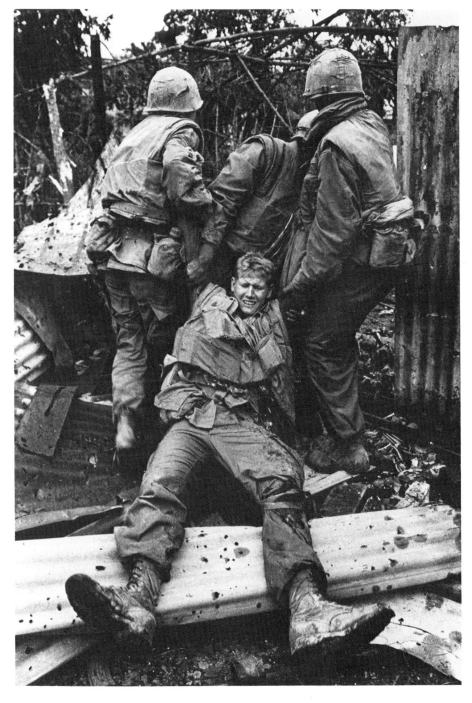

59. Don McCullin:
Wounded Soldier, Vietnam,
1968.
(Magnum)

McCullin was a free-lance photographer working for the *London Observer* when he began his involvement with war photography by covering the fighting in Cyprus in 1964. For this work he received the World Press Photography Award. McCullin, disregarding personal safety, photographed the street fighting and the victims gunned down in their homes.

He became a staff photographer for the *Sunday Times* of London. In 1967, he photographed the war in the Congo. But it was the Tet Offensive in South Vietnam in 1968 that became McCullin's baptism of fire. He was always in the most dangerous position and brought back the most spectacular pictures. McCullin's photographs spare no one's sensibilities. It is a tribute to the growing visual literacy of the public that his photographs can be published without offense. Still, there are some people who cannot look at Don McCullin's photographs.

McCullin has said, "The photographer must be a humble and patient creature, ready to move forward or disappear into thin air. If I am alone and witness to happiness or shame, or even death, and no one else is near, I may have had choices, one to be the photographer, the other the man; but what I try to be is human." And at another time he said, "It's easy to hide behind the camera."

He went on to photograph in Biafra, Cambodia, Bangladesh, Indochina, Northern Ireland. From Beirut to Belfast, Don McCullin made photographic documents of terror and man's inhumanity. It seemed as though Don McCullin had listened to W. Eugene Smith when he said, "If my photographs could cause compassionate horror within the viewer, they might also prod the conscience of that viewer into taking action."

In 1972, Don McCullin said:

> I have had an incredible taste of war and disgust for it. I have tried to photograph everything that is relevant to the situation whether it is beautiful or sad. I'll always photograph the bad things. I look for the atrocity. Someone may have been killed by the wayside and his body is rotting away and nobody cares that it was a human being and it was a person—a living person. I care, and I am going to photograph it—as horrible as it looks, I am going to photograph it. I am there, it is dangerous and I might get killed. I haven't much longer to go as a war photographer and I don't want to die for a few pictures. The trouble is here we are and is anybody taking any notice?

Don McCullin has been an extraordinary documentary photographer because he combines a cool professionalism with concern for the individual. He has been an effective witness to the agony and anguish of our times.

The Dignity of the Commonplace

IN MID-CENTURY, a new idiom of documentary photography appeared. These pictures, seemingly haphazard and elementary, showed Americans in the most ordinary, commonplace, and even banal activities. Yet, they were intensely disturbing and personal. They were views in ordinary public settings of sadness and disenchantment that had never been presented before. These photographs were made by Robert Frank, Garry Winogrand, Lee Friedlander, and Benedict Fernandez.

An Alienated Society Observed by Robert Frank

In order to understand the impact that Robert Frank made in 1959 when his book of photographs, *The Americans*, was published, it is necessary to appreciate the condition of society in the United States at that time. On a Guggenheim Fellowship, in 1955, Frank traveled by car across a country that was rich, tranquil, and eager to forget the Holocaust and Hiroshima. A respected soldier, Dwight David Eisenhower, was president. He promised and delivered peace and prosperity. The economist John Kenneth Galbraith wrote the classic, *Affluent Society*, which accurately described the achievements of free enterprise.

But under the surface there were fears of communism, subversion, war, and annihilation. A country weary from war twice rejected the intellectual Adlai Stevenson, who had strong ideas. Instead the voters continued to choose simple solutions. A growing civil rights movement was given new impetus by Dr. Martin Luther King who preached equality and nonviolence. The atomic scientist, J. Robert Oppenheimer, became a symbol of the repression of freedom as well as the hypocritical morality of government in control of science.

Documentary Photography

60. ROBERT FRANK:
Trolley, New Orleans, 1955.
(© Robert Frank)

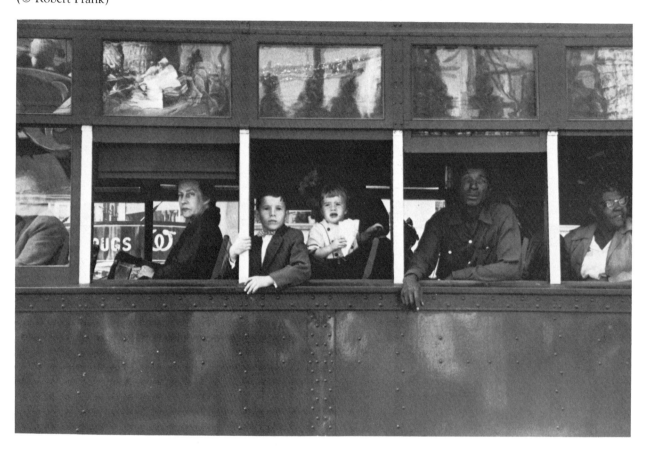

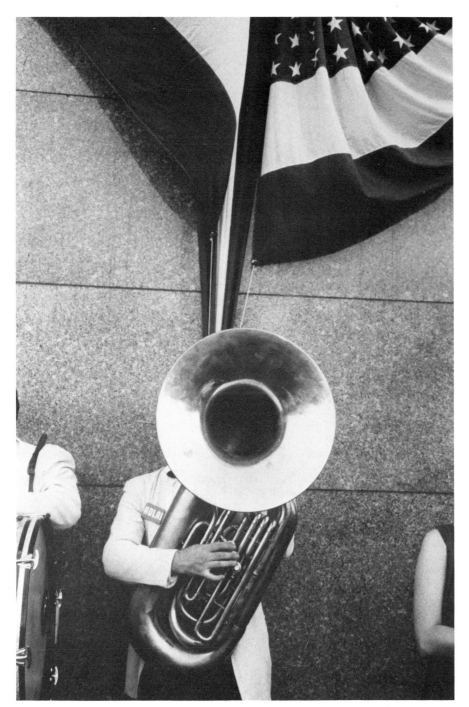

61. ROBERT FRANK:
Political Rally, Chicago, 1955.
(© Robert Frank.)

In the climate of materialism and anxiety of the mid-1950s, youth became alienated, as expressed by the actor James Dean in *Rebel without a Cause*, a film in which he played a sensitive adolescent fighting a world of conformity. Young Americans called themselves the beat generation, meaning "beaten down." They were disillusioned with the unattainable American dream of prosperity and conformity. Their prophets were the poet Allen Ginsberg and the writer Jack Kerouac whose novel *On The Road* sold half a million copies.

It was during these times that Robert Frank worked in the United States. He was born in Zurich, Switzerland, where he was educated and trained as a photographer. In 1947, Frank came to New York and photographed fashions for *Harper's Bazaar*. He was then a free-lance photographer whose work was published in *Life, Look*, and other magazines until 1955, when he started his two-year journey across the United States leading to the publication of his most important and influential documentary photo essay, "The Americans."

Although Robert Frank admits being influenced by Cartier-Bresson, André Kertész, and Walker Evans, it was Evans's friend, Ben Shahn, who made pictures thirty years earlier that seemed to be most like Frank's in style and subject matter.

Like Shahn, photographer Frank used a 35mm camera, small and unobtrusive, that allowed him to capture his subjects unaware. The 35mm camera had a unique ability to preserve what was ephemeral—a fraction of time, a fleeting image.

Ben Shahn once said, "I photograph for two reasons—either because I like certain events, things or people with great intensity or because I dislike others with equal intensity." Frank's pictures had that intensity. They captured the agonies and the ironies of life in America. His selective eye recorded on film some of the most intelligent and complex compositions.

Although many of the earlier documentary photographers were concerned about society and made photographs so that action could be taken to remedy its ills, Frank did not have that mission. He said, "I had never traveled through the country. I saw something that was hidden and threatening . . . You felt no tenderness."

In his memorable documentary photo essay "The Americans," Robert Frank showed isolation among overcrowding, cold facades, eyeless windows, doors that opened only to barren desolation. He showed the highway and the worship of the automobile, the despair and depressive boredom of everyday life. Frank said, "With these photographs I have attempted to show a cross section of the population. My effort was to express it simply and without confusion."

His photographs are provocative because they tell us things we would rather not know. By showing us how we are in these cold, clear, and cynical pictures, Frank suggests that there are problems.

The photographs of Robert Frank were the visual equivalent of the songs of folksinger Bob Dylan, who described the frustrations and alienations of the generation growing up in the United States during that time. Like Dylan, he knew the poet Allen Ginsberg and the writer Jack Kerouac, both strong voices of their times.

Frank brought the photographic style of Ben Shahn into his own generation and gave it a contemporary meaning. The subjects that Shahn tried to portray were, as he said, "Aloneness; the impossibility to communicate with each other, which accounts for the aloneness: and the sort of indestructible spirit of man to keep us going beyond the time when he thinks it would be impossible to arrive anywhere." But Frank was less concerned with man's spirit. He was not a reformer; he was a realist who made a comment about life as he saw it. Frank said:

> I have been frequently accused of deliberately twisting subject matter to my point of view. Above all, I know that life for a photographer cannot be a matter of indifference. Opinion often consists of a kind of criticism. But criticism can come out of love. It is important to see what is invisible to others—perhaps the look of hope or the look of sadness. Also, it is always the instantaneous reaction to oneself that produces a photograph.

The Absurdity of Contemporary Life as Viewed by Garry Winogrand

In common with Robert Frank's approach and sharing a similar style and technique, Garry Winogrand reflected the absurdity of contempory urban life in his photographs.

Like Frank, Winogrand was a fast shooter. He made the taking of a picture a reflex action to the speeded-up thought process about a situation. His photographs show ordinary people doing ordinary things. Many are brief stories, some are paradoxical groupings, others are little confrontations.

Moving down the street, snapping briskly with his Leica and wide-angle lens, Winogrand made pictures with a deliberate tilt and distortion to create a disturbing effect. An observer unobserved, his whimsical sense of humor enhanced the effectiveness of his photographs. Some of his documentary images are frightening, some are funny.

Winogrand had no mission other than to see his world clearly, to know and reflect it. He made no attempt to judge society, but did make an effort to

62. GARRY WINOGRAND:
The Animals, 1969.
(Light Gallery)

show how it looked. He said, "I don't have messages in my pictures. The true business of photography is to capture a bit of reality (whatever that is) on film."

Winogrand made visual notes of the cryptic and often unfinished events that make up life's reality. Although his pictures seem to deal with the commonplace, there was always an element of strangeness that unsettled the viewer. Many of his photographs raise disturbing questions about life in America. He said, "No one moment is most important, any moment can be something." But from the hundreds of exposures that he made, he was very careful to select for printing only those that showed his own personal view of life, and for these he supplied no interpretations, leaving it all to the viewer. With characteristic wit, Winogrand said, "The way I understand it, a photographer's relationship to his medium is responsible for his relationship to the world is responsible for his relationship to his medium."

Born in New York City in 1928, Garry Winogrand joined the U.S. Air Force after graduating from high school. Using his veteran's benefits, he studied art at Columbia University where he was a member of the camera club. He obtained further instruction in photography at the New School. In 1952 he became a professional free-lance photographer, one of the group of photojournalists who worked exclusively with the 35mm camera and available light. He was strongly influenced by Robert Frank's documentary photo essay "The Americans."

Although Winogrand was doing well with commercial, advertising, and photojournalistic assignments, he continued to explore his personal style and finally was free to work at it full-time under a Guggenheim Fellowship in 1965. Other fellowships, grants, and teaching positions followed, making it possible for Winogrand to continue developing his original talent and individual vision. He died in 1984, in the prime of his creativity, from cancer, leaving a collection of unique photographs by a gifted and prolific documentary photographer.

The Complex Relationships and Juxtapositions of Lee Friedlander

One of the new generation of documentary photographers, Lee Friedlander also projects a disoriented and uneasy America in his photographs. He claims no pleas for change, nor does he make any judgments. Whatever the viewer sees in his pictures is his own business. He says,

> It fascinates me that there is a variety of feeling about what I do. I'm not a premeditative photographer. I see a picture and I make it. If I had a chance, I'd be out shooting all the time. You don't have to go

63. LEE FRIEDLANDER:
Cincinnati, Ohio, 1963.
(Zabriskie Gallery)

64. BENEDICT J. FERNANDEZ: *Victory in Vietnam Rally, New York City, 1967.*
(© Benedict J. Fernandez)

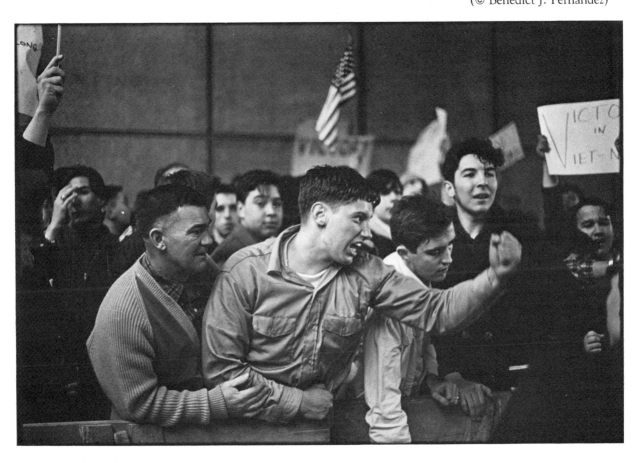

looking for pictures. The material is generous. You go out and the pictures are staring at you.

Although he credits Eugene Atget and Walker Evans as his influences, Friedlander works with a 35mm camera. He photographs almost every day. His camera, a Leica, is usually ready. Friedlander says that if he didn't photograph all the time, he would develop withdrawal anxiety. He takes pictures because he is curious about what things are going to look like as a photograph.

Many of Friedlander's photographs have unusual compositions. He works in spatial dimensions from front to back as well as side to side. As a result, his photographs seem deceptively carefree, like a snapshot. This contributes also to the frantic disturbed appearance of his urban landscapes.

With regard to composition, Friedlander quotes his contemporary, Garry Winogrand who, when asked what was the most important thing about Eugene Atget said, "He knew where to stand." So Friedlander is constantly searching for the right place to stand, to position himself, to choose the right subject, and to freeze time. With his sharp eye for the unnoticed moment that is meaningful, he produces his disquieting, perceptive visual comments.

Lee Friedlander was born in Aberdeen, Washington, in 1934. He studied photography at the Art Center School of Los Angeles and then in 1956 became a professional photographer doing commercial work, such as record album covers in New York. With the recognition of his art, the support of foundations and grants, and various teaching positions, he has been able to pursue his singular vision in photography.

Many books of Friedlander's photographs have been published. Walker Evans described one collection as "little poems of hate-bitterly funny observations." Friedlander's photographs with their seeming triviality and tortured detail often force the viewer to examine what might be ignored. They are both wry and persuasive. Friedlander says that his work is instinctive.

A photographer is stuck with that moment, so it is almost inevitably instinctive. You don't think about it before or after you do it. A painter or a writer can rework something, but a photographer really can't do it again. The sun goes behind a cloud and the whole thing changes. If you asked that question of an athlete, he wouldn't be able to say how he makes the choices in a game. Photography is quite similar to athletics—more so, maybe than to art.

Lee Friedlander has expanded the creative use of the snapshot principle in documentary photographic realism. He maintains that it is "harder than it seems. It seems simple, but a lot of it is there just to edit it down to what

matters. I think it's a hard medium because you can't take a photograph apart and rebuild it."

Whether deliberate, unconscious or instinctive, Friedlander uses the principles of control of the time and the frame to achieve his unusual images. From the changing, moving environment, he selects that combination of form and pattern to create balance and order. By choosing his relationships and juxtapositions, he defines the composition and thereby the ultimate meaning of his photograph.

Protest and Dissent Covered by Benedict Fernandez

During the turmoil of the 1960s, a photographer of dissent, Benedict Fernandez, documented the variety and diversity of those with different views. His vigorous, vital, action-stopping photographs of Americans expressing themselves in protest are records of human emotion. Benedict Fernandez, who grew up in El Barrio, one of the most vibrant sections of Spanish Harlem in New York City, learned to use his camera to make visual records of people with empathy.

The photographs of Frank, Winogrand, Friedlander, and Fernandez are more than a slice of life. They are true and surprising and show us new patterns of meaning.

65. Documentary
Photography Books.

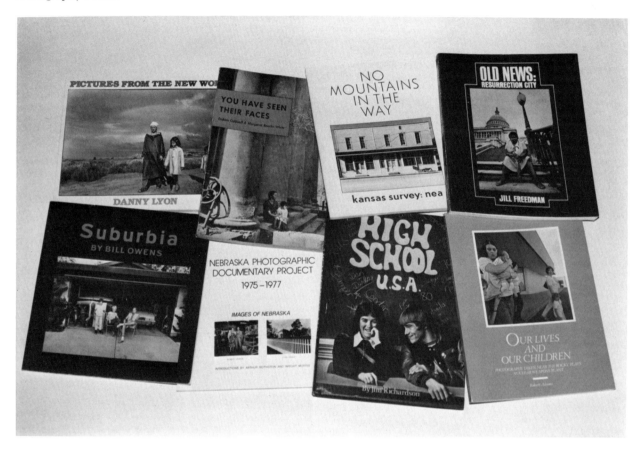

The Documentary Book

THE DECLINE of general-interest picture magazines and the subsequent loss of a showcase for the documentary photo essay has inspired many contemporary documentary photographers to produce this type of creative communication in book form.

Some of these have had a wide distribution and critical acclaim. For the most part, the concepts were originated and executed by the photographers. In some instances writers have added inspired editorial information to the visual statements of the photographers. Frequently, photographers have accompanied their photographs with captions and words designed to enhance the meaning of the image. A few books have been able to stand on their own as picture presentations without the benefit of words.

History of the Documentary Book

The tradition of the documentary photographic book started early in the history of photography with the publication in 1873 by John Thomson of his book, *Illustrations of China and Its People*. According to Thomson's introduction, "The photograph affords the nearest approach that can be made toward placing the reader actually before the scene which is represented." This book was followed in 1877 by Thomson's *Street Life in London*, also the earliest example of the continued preoccupation of documentary photographers with the lives of the poor and underprivileged. In the United States, Jacob Riis produced the book, *How the Other Half Lives*, in 1890, in which he documented with words and photographs the terrible conditions in the slums of New York City. He used his talents with the pen and camera to publish similar volumes: *Children of the Poor*, 1892; *Battle with the Slums*, 1902; and *Children of the Tenements*, 1904.

Other early examples of significant photographic books were Lewis Hine's *Men at Work* in 1932 and Brassai's *Paris de Nuit* in 1933. Although Lewis Hine's *Men at Work* was an early example of a documentary picture book, the beginning of the modern approach to this form was *You Have Seen Their Faces* in 1937 with photographs by Margaret Bourke-White and text by Erskine Caldwell. Author of the best-selling book and longest running play on Broadway, *Tobacco Road,* Caldwell invited Bourke-White to travel with him through the South in order to document the plight of the sharecropper.

The publication of *You Have Seen Their Faces* created a sensation. One critic wrote, "This book belongs to a new art, one that has to be judged by different standards." Another commented, "This is the South seen through the magic bitterness of text and the magic eye of a camera." For Bourke-White it was the realization of her hope—through the fusion of words and pictures she and Caldwell had created something new.

A year later, Archibald MacLeish produced a picture book titled *Land of the Free.* It consisted of eighty-eight photographs selected by MacLeish from the files of the Farm Security Administration and arranged by him to accompany his poem, which MacLeish termed "the sound track." The book is not a poem illustrated by photographs, but as MacLeish has stressed, "It is a collection of photographs illustrated by a poem. The poem has a subject of its own but it was written out of the photographs in the sense that the photographs held the great, tragic experience which the poem attempted to put in perspective."

Another major documentary picture book was *An American Exodus,* published in 1939, a collaboration between Dorothea Lange and Paul Shuster Taylor. The theme of the book was the mass migration mainly to California of three hundred thousand refugees from farms in the Great Plains states. The authors said that they were producing "neither a book of photographs nor an illustrated book in the traditional sense." They rejected what Caldwell and Bourke-White had done. In their foreword, Lange and Taylor declared, "We adhere to the standards of documentary photography as we have conceived them. Quotations which accompany photographs report what the persons photographed said, not what we think might have been their unspoken thoughts."

The Impact of Words and Pictures

An American Exodus was described by Beaumont Newhall as "a bold experiment, pointing the way to a new medium, where words and pictures do not merely explain and illustrate; they reinforce one another to produce the 'third effect'." This combination of words and pictures was pursued by the new picture magazines, *Life* and *Look,* and for thirty-five years, they became the

outlet for this type of documentary effort. During this period, picture books appeared by and about practically every documentary photographer, but they were mainly of a retrospective nature. Of this type, a noteworthy example is *The Decisive Moment* by Henri Cartier-Bresson, which was printed in France in 1952 with a cover by Matisse.

As developed to its ultimate state of refinement, the documentary photo essay or picture story has certain basic principles. One is the idea of expressing the general through the specific. A universal theme can be presented by concentrating and limiting the scope of the coverage. Another fundamental is to tell the story in terms of people and their activities. Finally, the choice of words to accompany the photographs is critical.

Photographs can be viewed and appreciated without words, and some photo essays have demonstrated this, but generally, photographs are more effective when accompanied by information that is not evident from seeing the picture.

A photograph may raise doubts and questions. The writer can supply the answer. He may identify people, places, or objects. He can fix the time. He can describe those other nonvisual senses—sound, taste, smell, feel. Emotion can be confirmed. Thus, words and pictures become complementary.

The Variety of Documentary Books

However, some photographs can stand on their own. For example, from 1966 to 1968, Bruce Davidson photographed the people of East 100th Street in Harlem in New York City. Afterward, Davidson said, "I decided to take the collection of photographs to publishers. They said that they needed a written text, but I refused. I couldn't use words to break the trust that people gave me standing silently before the camera in that still suspended moment when they looked into themselves and out at the world." Eventually the photographs were exhibited at the Museum of Modern Art and published in book form by Harvard University Press.

Bruce Davidson has always been involved with the lonely, deprived, and forlorn people of the world, delving into the deep and intimate moments of their lives as a way of illustrating their needs. He has been described accurately as a concerned photographer. Born in Oak Park, Illinois, a suburb of Chicago in 1933, he studied photography at the Rochester Institute of Technology and also at Yale University. After two years in the U.S. Army, Davidson became a free-lance photojournalist in 1958.

Davidson started with a candid, unobtrusive style of photography and a 35mm camera. For his East 100th Street photo essay, he abandoned anonymity and chose a 4-×-5-inch camera on a tripod. He said, "When you are

working with a view camera on a heavy tripod, the only thing connecting you and the instrument is your little finger on the cable release. You stand there looking, seeing the whole scene at once."

This method of working also required trust, friendship, and cooperation with the photographer and his subjects as he documented their lives. This deliberate approach resulted in more revealing details. Davidson's photographs showed beauty in the meanest surroundings. They document with sympathy people and their environment that many would overlook rather than have their plight on their conscience.

From the beginning of his career, Danny Lyon was involved with the recording in documentary photographs of social and cultural life in the United States. His first book, *The Movement,* resulted from his political involvement in the civil rights movement in the 1960s.

Danny Lyon was born in Brooklyn, New York, in 1942. He graduated from the University of Chicago in 1963, and while there he was the staff photographer for the Student Non-Violent Coordinating Committee. He then rode and photographed for two years with the Chicago Outlaws, a club of motorcycle bikers.

This work resulted in a book *The Bike Riders* in 1968. In it, Lyon showed with photographs and verbatim conversations the rituals and customs of these antisocial young people. His photographs show them in action, working on their machines, riding with their women. Using a tape recorder, the transcribed text in the form of conversations, monologues, and interviews enhances the visual information in the photographs.

Another book, *Conversations with the Dead,* shows life in the prisons of Texas. Without condemnation of the authorities or any judgment, Lyon's photographs of the conditions in which men live in captivity are humanistic and compassionate.

Because Lyon participates directly in every project he undertakes, his books have an undeniable conviction. He says, "Photographers traditionally have worked in silence, putting everything into the picture, that small area measured in inches that they have staked out. I have never done that, but have usually presented by photographs in books with a text. In the text I have spoken through other people's voices, sometimes out of respect for what they had to say and sometimes as a disguise for myself."

Larry Clark's reputation as a documentary photographer was immediately established with the publication of his book, *Tulsa,* in 1971, when he was twenty-eight years old. In the manner of Robert Frank's *America, Tulsa* had great impact. Clark was both an observer and a participant in the underworld drug culture of middle America in the 1960s. During the Vietnam War years,

66. DANNY LYON:
*Crossing the Ohio River,
Louisville, 1966.*
(From *Pictures from the New
World.* © Danny Lyon)

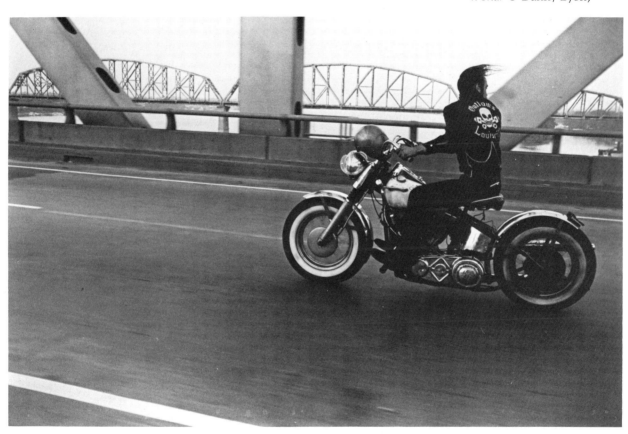

his camera recorded the grim, violent lives of his friends with their hypodermic needles and their guns.

Larry Clark has said that both Dorothea Lange and Eugene Smith were important influences. But his work shows little of the sentiment and humanism that they had. Instead, his photographs are powerful and their statements are convincing because they lack pathos and compassion. Like Danny Lyon, the photographs of Larry Clark result from his own active participation in the world he photographs.

He was born in Tulsa, Oklahoma, in 1943 and studied photography at the Layton School of Art in Milwaukee, Wisconsin. Clark served in the U.S. Army in Vietnam from 1964 to 1966. He then became a free-lance photographer and was able to pursue his documentary photographs with grants from various agencies.

In another book, *Teen Age Lust*, published in 1984, Larry Clark presents a vivid aspect of America as an autobiography. With eighty-three black and white photographs and twenty-seven pages of text, Clark documents his Tulsa years, his travels in New Mexico and California, his arrest in Oklahoma City, his time in McAlester Prison, and his observation and sharing of the disorderly crime scene in the Times Square area of New York City. Larry Clark has set a style in documentary photography—that of the harsh, realistic, stream-of-consciousness, personalized, shocking, and disturbing image.

With wit, humor, and objectivity, Bill Owens became the recorder of middle class America. His book *Suburbia*, published in 1973, is in the best documentary tradition. Using saturation coverage of a specific segment of society, Owens presents a massive amount of information. His photographs and text provide raw material for the viewer without drawing conclusions. He has no preformed ideas, but invites interpretation. The use of clear, well-lit black and white photography draws attention to the subject and encourages concentration.

In his introduction to *Suburbia*, written in the summer of 1972, Bill Owens says:

> This book is about my friends and the world I live in. In the fall of
> 1968 I began working as a photographer for the Livermore (California)
> Independent. My daily routine took me into the homes of hundreds of
> families and into contact with the social life of three suburban communities.
>
> The people I met enjoy the lifestyle of the suburbs. They have
> realized The American Dream. They are proud to be home owners and
> to have achieved material success.

67. BILL OWENS:
Companions of the Forest of
America, Livermore,
California, 1975.
(From *Our Kind of People.* ©
Bill Owens)

To me nothing seemed familiar, yet everything was very, very familiar. At first I suffered from culture shock. I wanted to photograph everything, thousands of photographs. Then slowly I began to put my thoughts and feelings together and to document Americans in suburbia. It took two years.

The photos in this book express the lives of the people I know. The comments on each photograph are what people feel about themselves.

Owens was born in San Jose, California, in 1938. After graduation from college in 1963, he served for two years in the Peace Corps. As a staff photographer for the *Livermore Independent,* he was an accepted member of that suburban California community. After completing his newspaper assignment, Owens made documentary photographs for himself of his friends and neighbors. The collection in *Suburbia* was described as "human, factual and sincere." Owens's second book in 1975 was *Our Kind of People,* subtitled *American Groups and Rituals.* It revealed the life of people in the Livermore area, their civic, social, and fraternal organizations.

Owens described his way of working: "I would take the required news photo and then continue photographing the group's activities for the next two or three hours. I also spent weekends and evenings attending meetings, gatherings and musters; over 300 groups were photographed, some of them two or three times before I got the photo I wanted. After 15 months, I stopped taking pictures and began assembling and editing the captions."

Bill Owens's dedication to the documentary ideal is evident when he says, "The heart of photography is the documentary image, as it is a record of people, places and events. The challenge to the documentary photographer is the highest, as the photograph must be technically perfect and show how people live. The documentary photograph contains the symbols of our society and tells us about ourselves. This type of photography, if properly done, will stand the test of time."

As a documentary photographer, Jill Freedman also believes in total involvement with her subjects. From her first book which described the march of poor people on Washington, D.C., to her latest on the police of New York, she has made a thorough commitment to the truth about the people and scenes that she photographs. Her photographs are sensitive yet objective, realistic yet compassionate, dramatic yet light-hearted. They show the forlorn and the brave so that we are informed and educated about aspects of our society.

Jill Freedman was born in Pittsburgh, Pennsylvania, in 1939. She at-

68. JILL FREEDMAN:
Circus Days, 1971.
(Rothstein Collection)

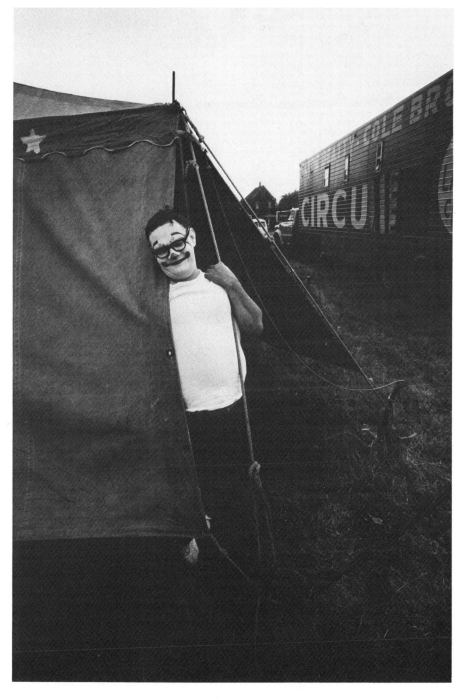

Documentary Photography

69. JILL FREEDMAN:
Street Cops, 1980.
(International Center of
Photography)

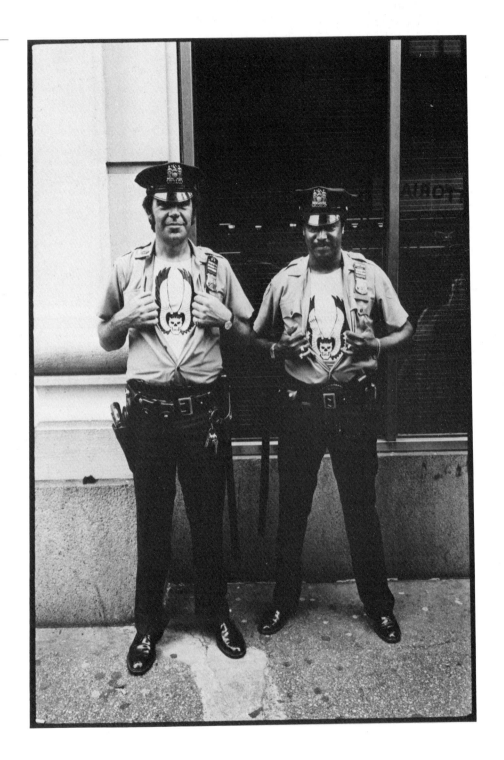

70. MARY ELLEN MARK:
*Mother Teresa, Calcutta,
India, 1980.*
(© Mary Ellen Mark)

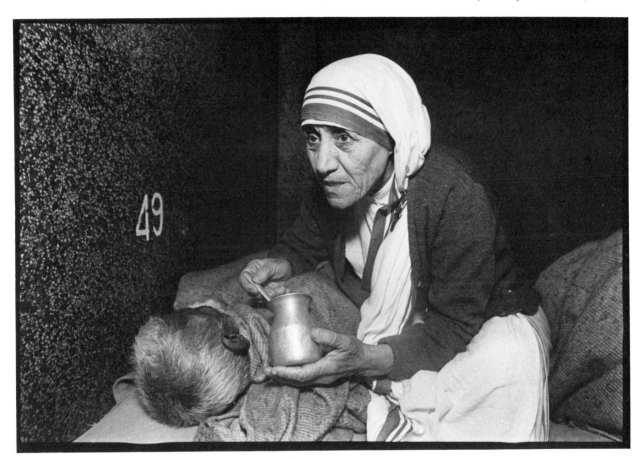

71. MARY ELLEN MARK:
*Lillie, 12 Year Old Street Kid,
Seattle, Washington, 1983.*
(© Mary Ellen Mark)

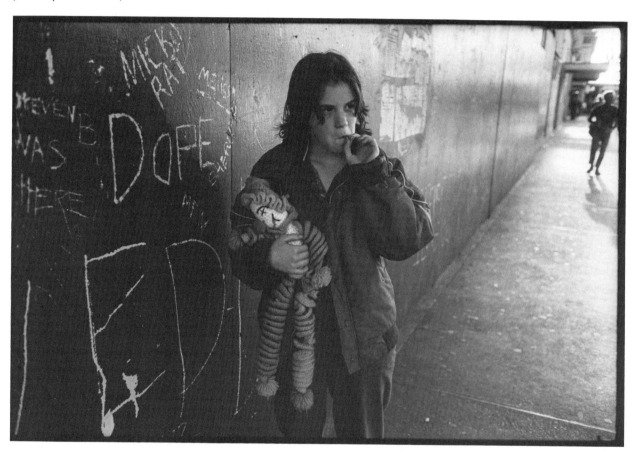

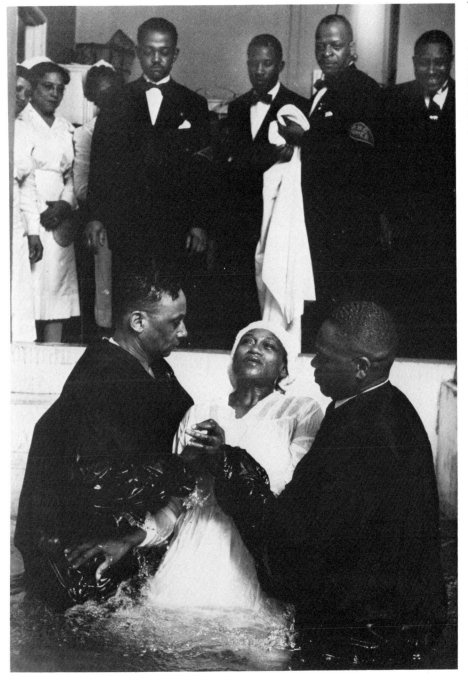

72. GORDON PARKS:
Baptism, Chicago, 1953.
From *Moments Without
Proper Names, 1975.*
(International Center of
Photography)

Documentary Photography

73. GORDON PARKS:
*Black Muslim Women,
Chicago, 1963.*
From *Moments Without
Proper Names.*
(International Center of
Photography)

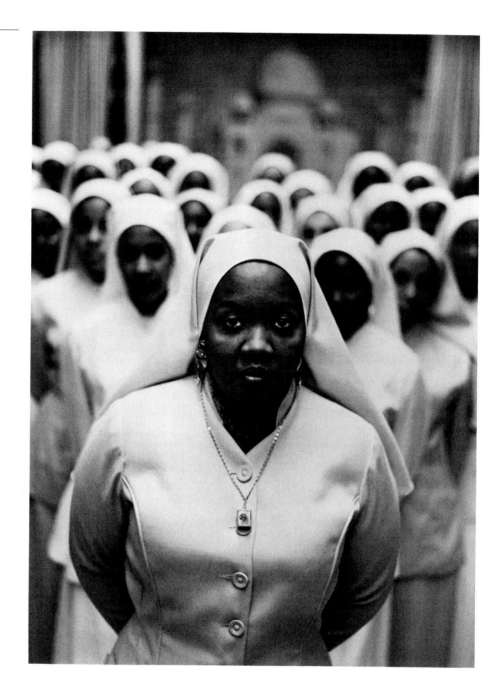

tended the University of Pittsburgh and was self-taught in photography. Her first photo book was *Old News, Resurrection City* in 1970, followed by *Circus Days,* 1975; *Firehouse,* 1977; and *Street Cops,* 1981.

Another photographer who documents our world in books is Mary Ellen Mark. Her first major publication was in *Look,* a report on a drug clinic in London and the approach to heroin addiction in England. This started Mary Ellen Mark on a series of projects about the human condition at many levels of society and in many countries. Her photographs are factual, honest, and truthful.

In her book *Ward 81,* published in 1979, are photographs that shock and disturb because of their haunting images and frank portrayal of mental illness. She said, "The photographs were taken in 1976 in a maximum security ward for women in the Oregon State Mental Hospital. I was permitted to live in the ward with the women for two months. In my photographs I tried to give some insight into the anxieties and mood changes of these women, as well as show the conditions of their confinement."

Mary Ellen Mark was born in Philadelphia, Pennsylvania, in 1940. She received a B.F.A. degree at the University of Pennsylvania and a Master of Arts in communication. In addition to a wide variety of essays for many magazines, she has published books on the prostitutes of Bombay, India, *Falkland Road,* 1981, and the charitable work of Mother Teresa in Calcutta.

A book in the classic tradition, using photographs and words of the subjects, is Jim Richardson's *High School, USA,* published in 1979. At Rossville High School in Rossville, Kansas (population 1,000), Jim Richardson spent three years capturing the universal nature of the high school experience, in the relationships of students, parents, and teachers. The result is a document of American social history produced with great personal insight. Although his photographs are documentary, Richardson says, "This is no unbiased report. I have a deep respect for the kids of Rossville High School. Sometimes it borders on love. I like them the way they are without embellishment or glossing over." In order to obtain the words that accompany the pictures, Richardson used a tape recorder to question his subjects while maintaining the truth and flavor of their statements with a minimum of editing.

Jim Richardson was born in Belleville, Kansas, in 1948. He attended Kansas State University and worked as a staff photographer with the *Topeka Capital Journal* and the *Denver Post.* He has also produced a documentary study of the small town of Cuba, Kansas.

A fine example of the autobiographical documentary photographic book is *Moments Without Proper Names,* published in 1975 by Gordon Parks. As a poet, musician, writer, and photographer, Parks has been a creative inspira-

tion. Born in Fort Scott, Kansas, in 1912, he worked with Roy Stryker in the Farm Security Administration's later years and then with the documentary photo project of the Standard Oil Company of New Jersey, also with Stryker. In 1948, he became a staff photographer for *Life*. His photo essay on Flavio, a boy of the slums in Rio de Janiero, generates power and concern by its honesty and directness. Parks covered the civil rights movement of the sixties, and his images made that period of upheaval and frustration understandable.

In *Moments Without Proper Names*, Parks deals with his deprivation as a child, the bigotry and inhumanity to which he was exposed, and the pleasures of the privileges that he has known as a successful journalist and filmmaker. He says, "Time has taught me that it is not enough to look, condemn, or praise—to be just an observer. I must attempt to transcend the limits of my own experience by sharing, as deeply as possible the problems of those I photograph. In helping one another we can ultimately save ourselves. We must give up silent watching and put our commitments into practice."

In 1976, a very strong documentary book appeared with photographs by Mark Jury and his brother Dan and text by Mark Jury. Titled *Gramp*, it is the extraordinary record of one family's encounter with the reality of dying. It is about Mark and Dan's grandfather Frank Tugend, and it records the last years of his life, from the first onset of senility until his death. Everyone who sees this book is enormously affected by the photographs and text.

Mark Jury said that his and his brother's decision to document daily the final weeks of a person who welcomes death was not insensitive photography. "We loved Gramp. We thought of it as a human and family experience we were sharing with countless other families facing the same problem. And we are sure most of them are as unprepared for the experience as we were."

An example of a book that uses no words, yet conveys a disturbing sense of terror on a contemporary theme, is Robert Adams's *Our Lives and Our Children* published in 1984. The subject is the reaction of people to what may be a nuclear accident, and as such it is representative of the threat to all humankind from nuclear weapons. The remarkable aspect of these documentary photographs is the buildup and rising tension created by the photographer in his approach to the subject, and his deliberate and honest technical methods to make a strong comment.

Robert Adams has photographed landscapes and architecture in the western United States. He was born in Orange, New Jersey, in 1937 and has a Ph.D. in English from the University of Southern California at Los Angeles. He is a writer and a photographer who says,

> The subject of most of my pictures is a troubling mixture: buildings
> and roads that are often, but not always, unworthy of us; people who

74. Lewis Baltz:
San Quentin Point, #26,
California, 1983.
(Castelli Gallery)

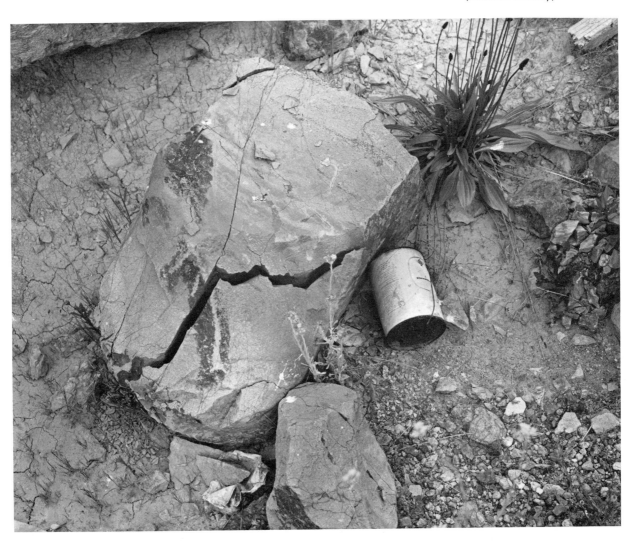

75. DAVID PLOWDEN:
Ore Stockpile and Steel Mill,
East Chicago, Indiana, 1981.
(© David Plowden)

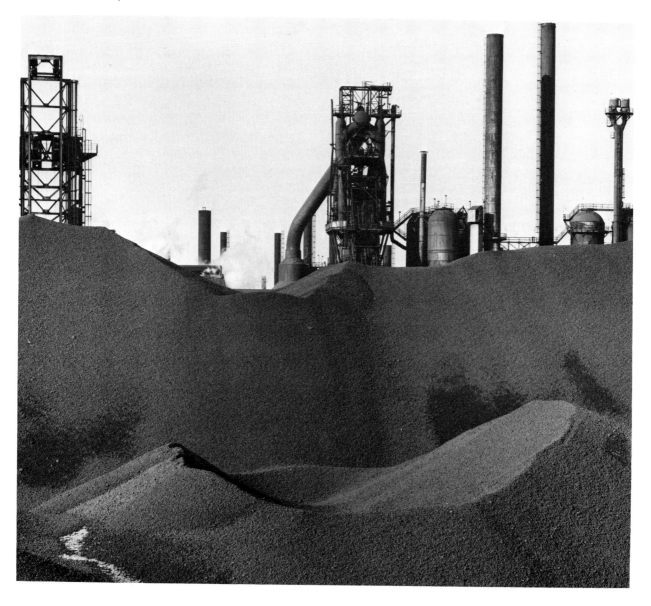

are, though they participate in urban chaos, admirable and deserving of our thought and care; light that sometimes still works an alchemy; a western scale that, despite our crowding, persists in long views.

With a spare documentary style that emphasizes maximum clarity, Lewis Baltz has also photographed in the western United States, concentrating on landscapes. His unemotional and informational approach is similar to that of Robert Adams. Their work has been described as the New Topographics.

Lewis Baltz was born in Newport Beach, California, in 1945. He has a B.F.A. from the San Francisco Art Institute and an M.F.A. from the Claremont Graduate School. Baltz has received National Endowment for the Arts and Guggenheim grants. He has taught photography at various California schools. Baltz makes his pictures in series in order to accumulate evidence. His images become metaphors that describe the mortality of life. Some of his documentary photo essays are: "Nevada," "Park City," and "San Quentin Point."

A prolific producer of documentary photo books is David Plowden, whose fourteenth and most recent effort is *An American Chronology*. He says:

> One thing that I have come to understand by making pictures is the unique power of the photograph to convey a sense of presence; to preserve—what was there. This makes it possible for anyone who sees the photograph to explore that place or subject as if he were there and to bring his own associations to the image, even if the physical subject of the photograph has long since ceased to exist.
>
> If the artifacts of the past generation's accomplishments hold a key to a better understanding of its attitudes and priorities, then the physical evidence of the present should be able to tell us something about the achievements of our own time . . . and perhaps also about what might lie ahead.

Documentary Photography

76. CHARLES O'REAR:
Farming near Blythe,
California, 1972.
(U.S. Environmental
Protection Agency)

Color

FROM THE BEGINNING OF PHOTOGRAPHY, color has been an essential and powerful element for the documentary photographer. All the pioneers of the nineteenth century, such as Joseph Nicephore Niepce and Louis Jacques Mande Daguerre, tried to make permanent color images, but they could not fix their images. In 1891, a physicist at the Sorbonne, Gabriel Lippman, invented a photographic plate that produced color by light interference. For this achievement, he won a Nobel Prize. However, his process had technical obstacles that made it impractical for commercial use. His theories, however, are used to this day in the hologram.

The first practical commercial color materials were screen plates—panchromatic black and white emulsions, exposed through combination microscopic filters of red, green, and blue, and processed by reversal to give a color positive. In 1907, Auguste and Louis Lumiere produced their Autochrome plates using this additive technique. Six years later, they were manufacturing six thousand plates a day, and they continued production for thirty years. Even though exposures of one or two seconds were required, many nature, travel, and scientific photographs were made on Autochrome plates, and they still preserve their delicate color values.

The introduction of 35mm Kodachrome in 1936 was a major breakthrough. The invention of Leopold Mannes and Leopold Godowsky, Kodachrome used the subtractive process with three emulsion layers. The Farm Security Administration photographers were among the first to use Kodachrome in their documentary work. In the same year, Agfacolor appeared with dye couplers in the emulsion to permit processing by the user. In 1942, Kodacolor film became available, the first material to achieve color paper prints in rich, clear colors. With the introduction of Polacolor film in 1963,

the photographer could produce color prints in a minute after the click of the shutter.

Most photographs are now made in color. The number of exposures on black and white emulsions declines every year. For the needs of the documentary photographer there are special considerations in the choice of color. One is the depiction of reality. Color certainly adds more information to a scene. But not every color photograph is as realistic as a picture of the same scene in black and white. A basic difference, for example, is that contrast in black and white results from values of light while contrast in color results from the juxtaposition of complementary hues. Further, due to the adaptation of the eye and brain in perceiving color, the viewer sees color as it should look rather than as it actually is. Although color film records the scene objectively, the eye sees color subjectively.

Color or Black and White?

As opposed to color, black and white photographs have an abstract quality that demands interpretation by the viewer. If the landscapes of Ansel Adams had been made in color, they would be totally different statements, perhaps not as effective. Color adds a picturesque quality to a photograph that in some cases may interfere with the stark, realistic message that the photographer intends.

When deciding whether to use black and white or color, the documentary photographer should consider the archival and keeping qualities of the material used. In some photographic applications, the image only needs to be preserved for a relatively short time, as, for example, in certain scientific records, oscillograms, forensic and medical pictures, passport portraits, identification pictures, and real estate photographs. However, documentary photographs for social purposes, serious photo essays about people and their environment, and historical records and surveys should be preserved for posterity.

Black and white prints and negatives that are properly processed, washed, and stored under favorable conditions have archival permanence, exhibit practically no deterioration, and may be compared to a book or an oil painting in their ability to last through the years.

Color photographs do not have this degree of permanence. The type of color material as well as the temperature and relative humidity of storage has a profound effect on the longevity of the picture. For example, Kodachrome lasts about twice as long as Ektachrome which lasts about twice as long as Kodacolor. Because of the dyes used, Cibachrome seems to fade less than other color papers. Dye transfer prints exhibit the greatest archival qualities.

Variations result also from the viewing, display, and storing of color photographs. Color slides will deteriorate under projection. Duplicates should be used and the originals kept under proper conditions. Color prints will fade when exposed to sunlight or fluorescent lights for any length of time. Such fading may be retarded through the use of an ultraviolet protective spray.

The great enemies of color are moisture, light, and heat. The ideal environment for preserving transparencies and prints is a dry, dark and cool place. Temperature should be below 70° F and humidity between 25 and 50 percent.

Some photographers freeze their color negatives or transparencies in special envelopes that adjust the atmospheric conditions that act upon the color, exclude light, and control dye stability. A good black and white print, made from the color, archivally processed, is further insurance.

For the documentary photographer, the choice of color material is critical. If Ektachrome film had been available to Mathew Brady during the Civil War, his priceless documents would have faded away by this time. On the other hand, the Kodachromes made by the FSA photographers in 1936, stored under ideal conditions in the Library of Congress, exhibit no changes at all.

Documerica

The most extensive documentary project in color photography was set up in 1972 by the U.S. Environmental Protection Agency (EPA). That was also the year when *Life,* long a showcase for documentary and photojournalistic efforts, ceased publication. The government project, Documerica, was the most ambitious undertaking since the FSA project of the 1930s. Like the FSA, its purpose was to document a crisis confronting the nation, to publicize the mission and accomplishments of the Environmental Protection Agency, and to accumulate a historical record of our crucial and decisive efforts to survive on earth.

There were important differences between the FSA project and Documerica. The former was done in black and white, the latter in color. The FSA project used about a dozen photographers, and Documerica employed about 130, each for two- or three-week assignments. For the FSA photographers, there was never a question about the government's rights to their photographs. Within Documerica, a controversy, never resolved, developed between the American Society of Magazine Photographers and the EPA over the rights to the photographs.

The director of Documerica was Gifford Hampshire, who had been a picture editor at the *National Geographic Magazine* before becoming a public affairs officer at EPA. He was inspired by Roy Stryker who directed the FSA

77. GENE DANIELS:
Cars Stacked in Junk Yard,
Escondido, California, 1972.
(U.S. Environmental
Protection Agency)

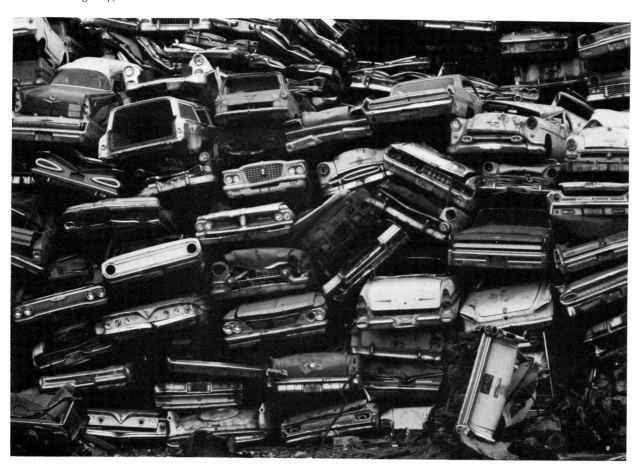

78. KEN HEYMAN:
*The Martin-Pena Area of
Puerto Rico, 1972.*
(U.S. Environmental
Protection Agency)

79. ARTHUR TRESS:
Breezy Point, Staten Island,
New York, 1973.
(U.S. Environmental
Protection Agency)

80. DAN McCOY:
Traffic on Sixth Avenue, New York City, 1973.
(U.S. Environmental Protection Agency)

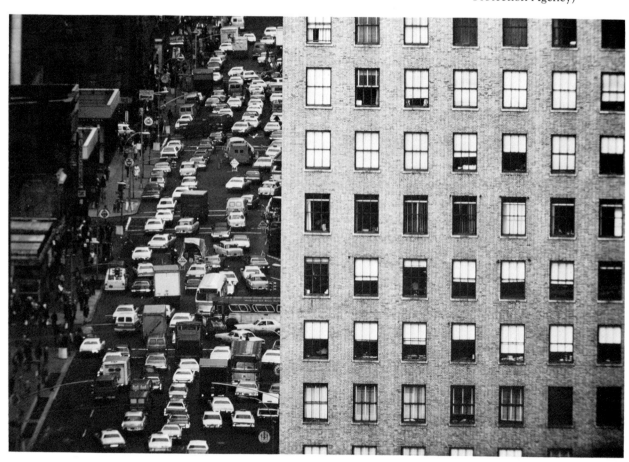

project, although Hampshire said, "The role of Roy Stryker can never be repeated by anyone."

For many years, some of the original FSA photographers and others, including Hampshire, believed that there should be another documentary project of similar scope to carry on the tradition of recording in photographs the evolution of the nation. Hampshire persuaded EPA officials to begin such a photodocumentary project to dramatize the problems of pollution.

In his definition of documentary photography, Hampshire said, "It is an honest approach by an individual who knows enough about the subject to establish its significance in present time and environment and for posterity." To assist the photographers on assignment, the district office and regional administrators of the EPA worked closely with each photographer to cover the major areas of pollution in air, water, pesticides, solid wastes, radiation, and noise.

After the 35mm Kodachrome transparencies were edited, they were transferred to microfiche and stored in a computer. A potential user could punch in the subject and location of pictures required and look at the appropriate images on a computer screen with caption information. For a nominal fee, duplicate transparencies of the original slides were available. When it ended in 1976, a file of sixteen thousand color photographs dealing with subjects and events in every part of the country had been assembled by Documerica.

The FSA photographs will live forever because they were made in black and white, but the Documerica color pictures have a more limited longevity. There is an urgent need for a color process that has the same economy, ease of use, and archival quality as black and white.

Grants and Programs

THE LIVING TRADITION of documentary photography continues to inspire dedicated artists to actively pursue and further refine their styles. The documentary photographer has an attitude toward the medium and the use of the image. This attitude is one of respect for the ability of the camera to define reality and the knowledge that social and cultural information can be assembled. The documentary photographer becomes a responsible observer who does more than prepare a literal report; one whose educational background, point of view, and sensitivity to contemporary events and surroundings make truthful comments and observations about society.

Dorothea Lange described this concept when she said, "A documentary photograph is not a factual photograph per se. The documentary photograph carries with it another thing, a quality in the subject that the artist responds to. It is a photograph which carries the full meaning of the episode or the circumstance or the situation that can only be revealed—because you can't really recapture it—by this other quality. There is no real warfare between the artist and the documentary photographer. He has to be both."

For a period in the seventies, a needless and pointless schism developed between documentary photographers and art-oriented photographers. This difference has fortunately disappeared and photographers who are committed to the documentary approach are now exhibiting their work in art galleries and museums.

Documentary photography is not the province of any one special interest. It has always been motivated by complex reasons, one of which was the creative, artistic impulse. Among the FSA documentary photographers, for example, Walker Evans and Ben Shahn considered themselves artists first and

Documentary Photography

81. KEN HEYMAN:
American Girls in Seville,
Spain, 1968.
(© Ken Heyman)

documentarians second. Yet they produced some of the greatest documentary photographs of the twentieth century.

Attempts to Revive the FSA Project

This temporary incompatibility, however, caused the failure of an attempt to create a new FSA type of documentary project. In 1975, Jess Gorkin, editor of *Parade*, wrote "an open letter to President Ford" in which he proposed:

> After two centuries of existence, the United States has achieved a way of life like none that has existed before. It is reflected in our great cities and rich farmlands, our busy scientific complexes and cultural centers, our manifold financial, commercial and athletic activities, our enduring social, religious and educational institutions. We would like to see this immensely varied and vibrant life of America preserved and documented for all time through the art of photography. We would like to see the government of the United States compile a photographic record of America today.

A well-known and highly competent documentary photographer, Ken Heyman, was asked to direct a project called Photo 200, but it failed to win the support of the National Endowment for the Arts and never became a reality. Twenty years earlier, Dorothea Lange had said, "The time is now ripe for another file along FSA lines." She called it "Project 1" and also wanted Ken Heyman to carry out her wish to create a new photodocument of American life.

Heyman is recognized as a sensitive interpreter of people. He was born in New York City in 1930 and went to Columbia University where he later collaborated with the famed anthropologist, Margaret Mead. With her, Heyman traveled to Bali, Mexico, Sicily, and other places. They produced two documentary books, *Family* in 1965, and *World Enough* in 1976. Heyman has photographed in more than sixty countries. In 1983, Ken Heyman published *The World's Family*, a collection of documentary photographs of men, women, and children around the globe showing family relationships and images of people at all ages from birth to death.

NEA Projects

Although a major documentary project for the entire United States—the dream of Heyman, Gorkin, and Lange—has not been realized, several states have developed documentary surveys of their own. With the aid of a grant from the National Endowment for the Arts, James Enyeart, then curator of

Documentary Photography

82. KEN HEYMAN:
Villagers of Byun Gede, Bali,
1970.
(© Ken Heyman)

83. JAMES ENYEART:
Perry, Kansas, 1974. From
No Mountains in the Way.
(© James Enyeart)

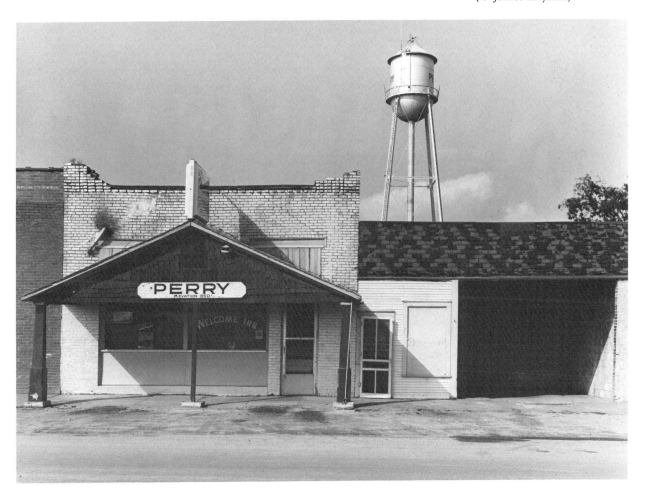

photography for the University of Kansas Museum of Art, started an "Aesthetic Survey of Kansas"; two other photographers, Terry Evans and Larry Schwarm, worked with Enyeart. Each photographed a different aspect of the state. Enyeart covered architecture, Evans was concerned with people, and Schwarm made pictures of signs and symbols. The museum in Lawrence, Kansas, published a book *No Mountains in the Way* in 1975, with the results of their work. In his introduction to the book, James Enyeart says:

> Nearly all documentary photographers manifest in their images their feelings, thoughts and attitudes by carefully selecting a particular aspect of the subject. There always seems to be present a self-conscious objectivity which allows the subject to be itself, free from dramatization or manipulation. Lastly, there is an apparent disregard for formal pictorial arrangement which, inspired by the nineteenth century, continues to dominate so much of photography today. Expressed in other words, one usually finds in a documentary photograph, honesty, empathy, and straightforward contact with the subject.

The successful completion of the Kansas project encouraged the NEA to invest in other such documentary surveys. From 1976 to 1981, the NEA provided support for more than two hundred photographers on various projects to be conducted in a documentary style. An exhibition, "Exposed and Developed: Photography Sponsored by the National Endowment for the Arts," was on view at the National Museum of American Art in Washington, D.C., in 1984. It included photographs from the Kentucky documentary project organized by Ted Wathen and funded by the NEA and several local sponsors. The other photographers were Bill Burke and Robert K. Hower. The three photographers were quite conscious of the evolution and influence of documentary photography, its traditions, and the role of individual photographers in shaping its history. Each of them was striving to blend all this knowledge and tradition, his own interests and abilities, and the subject before him into a unique and recognizable photographic statement.

Another NEA-funded project involved Ellen Manchester, Joanne Verberg, and Mark Klett. They traveled through the West photographing once again the same scenes that Timothy O'Sullivan had documented in the 1870s when he worked on the geological surveys west of the one hundredth meridian.

Although the NEA stopped funding photographic documentary projects in 1981, it continues to provide fellowships every other year to photographers for assistance in completing their projects, some of which may be documentary. An example is the extensive series on "Subways" by Bruce Davidson.

Rephotography: Bill Ganzel

The idea of rephotographing the same scenes in order to show the changes created by the lapse of time was carried out successfully by Bill Ganzel. In his book, *Dust Bowl Descent,* published in 1984, he retraced the routes of the FSA photographers and the approach that they used in chronicling the depression.

Over a period of ten years and travels in excess of fifty thousand miles, Ganzel sought the people and the sites in the FSA photographs. Pairing his own photographs with those made by the FSA photographers, Ganzel created a "serial documentary." He says, "An effective documentary photograph exists within, and derives much of its meaning and power from, its context." Bill Ganzel lives in Lincoln, Nebraska. He is associated with Nebraska Educational Television and continues to work on photographic projects.

Nebraska Photographic Documentary Project

Two other photographers in Nebraska, Robert Starck and Lynn Dance, supported by the Nebraska Arts Council and local contributors, produced an impressive documentary survey of their state. Robert Starck was born in 1945 in Lincoln, Nebraska. He graduated from the University of Nebraska in 1972 with his partner Lynn Dance who was born in 1949 in Los Angeles and has lived in Nebraska since 1955. They write:

> Change is a part of our lives—it surrounds and includes us, yet we may notice changes only in a backward glance. The Nebraska Photographic Documentary Project is intended to record in clear images the way Nebraskans live today, for this generation and for those who follow. We traveled throughout Nebraska documenting the life, landscape and architecture of the state. We sought out everyday people, from one end of the social scale to the other, who were not usually pictured in the daily newspapers or on television. Our approach was simple and straightforward.

The W. Eugene Smith Grant

Support for realistic documentary photography also comes from the W. Eugene Smith Grant in Humanistic Photography. It was established in 1980, two years after the death of Smith, whose passion for seeking the truth, often against great odds and financial hardship, had set the highest standards. The annual award encourages individual initiative for the creation of outstanding works that should not be abandoned for lack of financial support.

Documentary Photography

84. LYNN DANCE:
*Freirich's Farmstead, Talmage,
Nebraska, 1975.*
(© Lynn Dance)

85. ROBERT STARCK:
Coyote Hunter, Nebraska,
1976.
(© Robert Starck)

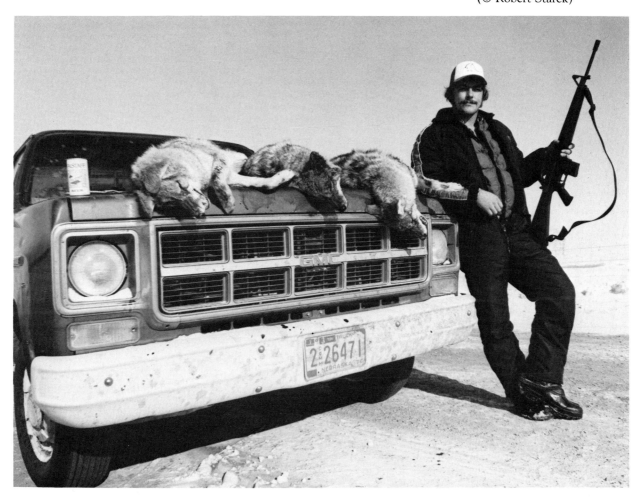

In 1980, the award was given to Jane Evelyn Atwood for a project in which she sought to make blind children better understood by the world that takes vision for granted; to Eugene Richards in 1981, to complete a photographic study of a hospital emergency ward, where the most sophisticated medical techniques confront, with compassion, the most violent aspects of society; to Sebastino Salgado in 1982, for documenting Indian populations in North America, seeking to reveal traits that he believes are shared by the descendants of all the hemisphere's original inhabitants; in 1983, to Milton Rogovin, a social documentarian who is completing a long-term photo essay on the coal miners of Appalachia and the Saar region of Germany; and in 1984, to Gilles Peress who has worked on projects that explore the social, political, and cultural fabric of modern society. Peress was born near Paris in 1946. He has documented a coal mining town in southern France, the Turkish immigrant workers in Germany, and the conflict in Northern Ireland. He received the Overseas Press Club Award in 1981 for his photographs of Iran.

White House Photography

A unique form of documentary photography conducted by the United States government is the detailed recording of the activities of the president.

Starting with Yoichi Okamoto, who photographed Lyndon Johnson, the White House has employed a staff of photographers to cover every detail of the chief executive's life. Many of these personal photographers to the president have enjoyed a close relationship with their subjects, for example, David Hume Kennerly with Ford and Michael Evans with Reagan. The resulting documentary file is a visual history of the presidency, an intimate and often revealing insight into the life of one who is normally carefully shielded and protected.

The concept of documentary photography has thus been defined, redefined, and expanded. It is a living tradition that reaffirms the efforts of the photographer who records the human experience with reality, the result of which is an image that stands the test of time.

86. CECIL STOUGHTON:
Lyndon B. Johnson Takes the
Oath of Office as President of
the United States on Air Force
One, November 1963.
(The White House)

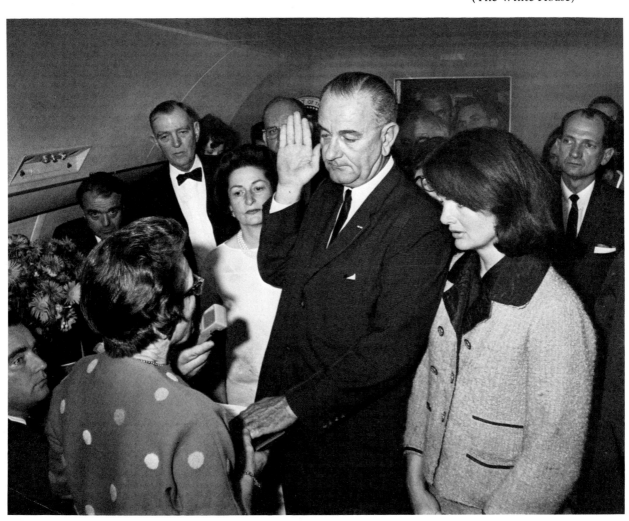

87. YOICHI R. OKAMOTO:
*President Lyndon B. Johnson
and Staff during the Dominican
Crisis, 1965.*
(The White House)

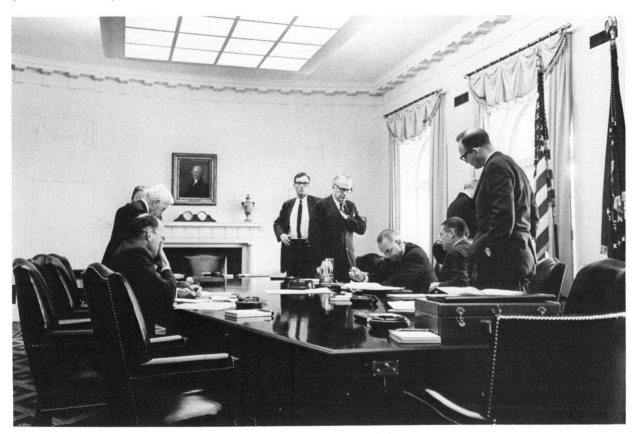

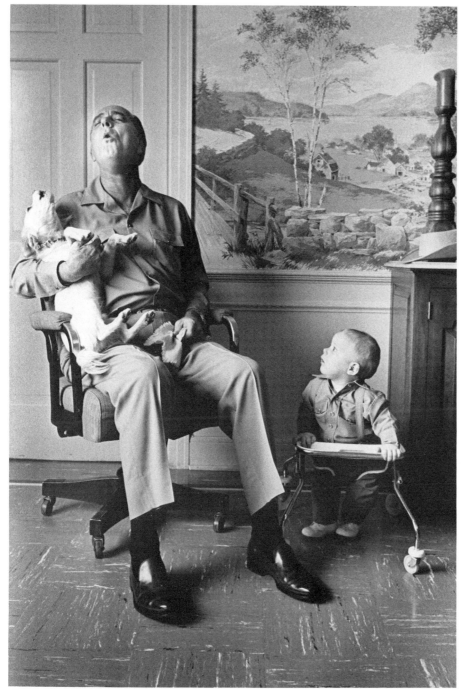

88. Yoichi R. Okamoto:
*President Lyndon B. Johnson
Howls with Dog, Yuki, as
Grandson Lyndon Watches,
LBJ Ranch, Stonewall, Texas,
1968.*
(The White House)

Documentary Photography

89. DAVID HUME KENNERLY:
*President Ford and Henry
Kissinger, 1975.*
(The White House)

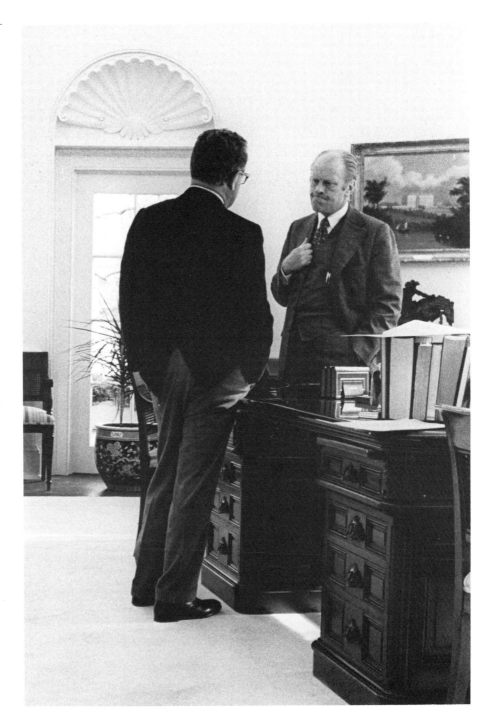

90 MICHAEL EVANS:
Nixon, Reagan, Ford, and
Carter, 1981.
(The White House)

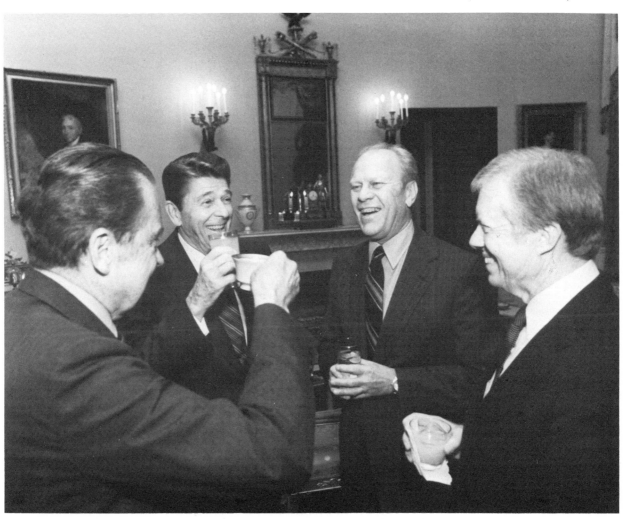

91. MICHAEL EVANS:
*President Reagan and Vice
President Bush, 1984.*
(The White House)

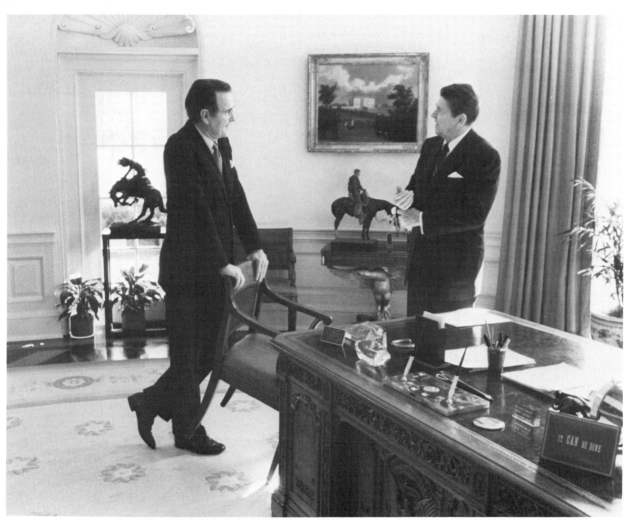

Methods and Techniques

THE PLANNING AND PRODUCTION of a documentary photographic project follows a logical sequence. The first step is to choose an appropriate subject. Universal interest in the material photographed is desirable so that the pictures reflect the experiences and feelings of large masses of people. Birth, death, hunger, wealth are understood by people everywhere.

A concentration of effort should also be a goal. For example, Bruce Davidson's *One Hundredth Street* was symbolic of a larger area and a more extensive group of minorities in New York City. This limitation of scope "focuses down," or expresses the general through the specific. The photographer should choose a practical and feasible subject, evaluating the difficulties and expenses involved in coverage and determining whether it is a viable, workable project.

Research and Preparation

In the process of subject selection, some preliminary research is needed, which should continue in depth when the decision to proceed is made. The more the photographer learns about the subject, the better the opportunity to select and photograph images with significance. Conversations with those who are familiar with the area and the people will be helpful. Reading books, both nonfiction and fiction, about the subject will give insight and understanding.

Planning the project involves such basic concepts as the best season of the year and the time of day or night. Whether to walk or use an appropriate vehicle and provision for housing and food should be considered. Financial problems must be solved. Details such as appropriate clothes and insect repellent are important.

At this stage, the photographer should prepare a shooting script. This is not a rigid and inflexible list of picture possibilities, but a checklist so that important items are not overlooked. While making photographs, many opportunities to produce good pictures will certainly arise spontaneoously. The shooting script is an aid to channel and direct the photographer's thoughts about the subject.

Equipment and Materials

The choice of equipment and materials can often determine the aesthetic content of the documentary survey. For the ultimate in detail, graduation, and tonal quality, a large format picture is best. A view camera with rising front, swings, and tilts is desirable for architectural work. The sharpness and detail of Walker Evans's 8-×-10-inch contact prints as well as his pungent observations combine to make his photographs masterpieces. The ability to capture the decisive moment, to freeze action at its most expressive instant was made possible for Henri Cartier-Bresson with the 35mm camera. The equipment selected should be appropriate to the subject. It can impose a method of working on the photographer that will determine the style of photography.

Obtaining Access

Before making photographs, the photographer should think about obtaining access to the subject. Passes may be necessary; permissions must be obtained. In these days of heightened picture consciousness and concern about invasion of privacy, some situations may require legal releases before the photographs can be used. Until her death in 1984, Florence Thompson, the migrant mother in Dorothea Lange's famous photograph made in 1936, believed that Lange had made a fortune from her picture. In reality, the picture was in the FSA files, the property of the U.S. government and in the public domain. Dorothea Lange never received anything for the many times the photograph had been reproduced.

Some photographers depend on local guides and people known to the community in order to obtain access. Letters written in advance are helpful in opening doors and providing welcome courtesies. Passports, visas, and insurance may be required.

Successful Shooting

Adequate preparation, research, and planning lead to successful shooting. When making pictures, the photographer should respond to the subject with as many exposures as necessary to ensure complete coverage, remembering the old saying "Film is cheaper than shoe leather." The photographer may

never be able to return to the scene and duplicate the lighting, the weather, or the subject. With 35mm, a common ratio is to make ten exposures for every one that is finally selected. Henri Cartier-Bresson said, "We photographers deal in things which are continually vanishing, and when they have vanished, there is no contrivance on earth which can make them come back again. We cannot develop and print a memory."

The photographer must learn to see with greater acuity. Both foreground and background should be considered. Sensitivity to light, alertness to changing situations, anticipation to reactions, choosing the correct angle and viewpoint, and knowing where to stand are all critical elements in making the photograph. Many documentary photographers have found that including signs in their picture creates a built-in caption. Another technique is the "third effect," a juxtaposition of contrasting elements to make a new observation.

Processing and Editing

Exposed film should be processed promptly to avoid deterioration of the latent image, within three weeks of exposure if possible. In all cases, archival processing is essential. In black and white work, the photographer has the most control over the longevity of the photograph. Fiber-based papers last longer than resin-coated ones. Proper fixing, washing, and toning of the print is necessary for making the image permanent. A clearing agent can be used to change the thiosulphate in the fixer into a more soluble chemical that washes out quickly. Permanence and quality are enhanced by using a selenium toner. Thorough washing and circulation of prints is followed by air drying on nylon or fiberglass screens. Many photographers use a one-inch border of unexposed paper as a protective frame for their prints.

After processing, prints and negatives should be stored in archival boxes and sleeves. Acid-free portfolio boxes are available for safe print storage. Polyethylene or polyester negative and transparency envelopes that do not contain polyvinyl chloride or sulfur should be used.

The editing and selecting of photographs for the documentary file is a serious, essential operation. The total impression may be determined by what is included or discarded. The photographer must forget about the difficulty involved in taking the pictures and evaluate them objectively. It is better to be generous in selection rather than be too critical—the passage of time has a way of making some photographs more meaningful. The editing of the FSA photographs was one of the biggest elements of controversy, particularly between Roy Stryker and Dorothea Lange. Stryker punched holes in some nega-

tives that he did not find acceptable, and many of the photographers found this to be an extreme form of prejudice.

Adding Captions

Documentary photographs need words to complete the information that the photograph presents. The photographer should provide the answers to the questions who, what, where, when, and why in order to make the photograph more useful. The captions accompanying a picture should be concise and complete. It should be written during the editing process from notes taken during the shooting. Some photographers use a cassette recorder to preserve the words of their subjects and to record other details about the objects and the area being photographed. While on location, accumulate maps, brochures, pamphlets, and other descriptive material. Photograph signs, markers, and plaques as additional memory aids. Captions should be written on the negative or transparency envelopes and transferred to prints as they are made.

Filing System

The value of a collection of documentary photographs is increased by the ease of their retrieval from the file. This requires the establishment of a good numbering and filing system. One simple method is chronological. Start with the year, followed by month and day, then a sequential number. For example, 85-7-17-1234. When 35mm is used, each roll can be contact printed with the file number on both the negative envelope and the 8-×-10-inch contact sheet. Since individual frames are numbered, they can be readily identified.

Finally, the accessibility of the material will determine its usefulness. Some collections are inhibited by legal restrictions; others are hard to locate and buried in remote warehouses. The power and impact of great documentary photographs demand that they be seen, exhibited, and published in order to influence, educate, and inform the public.

Suggestions for a Documentary Photographic Study of the Small Town in America

This outline, which went to all FSA photographers, resulted from a luncheon and afternoon session with Professor Robert Lynd, author of *Middletown.* Our meeting was at the Columbia University Faculty Club, Morningside Heights, New York City, sometime early in 1936.

I had brought up a collection of Farm Security Administration photographs to show Mr. Lynd. As he looked at these pictures, he became quite enthusiastic about the camera as a tool for social documentation.

The notes I made from his conversation that afternoon were the basis of this outline.

Roy E. Stryker

The ideal manner to conduct this experiment in photo-documentation would be to concentrate on a series of carefully selected towns of about 5,000 population. These would be "cross-roads" towns representative of the geographical area in which they are situated.

- Certain questions come to mind when considering such a project.
- Is there a social and economic pattern common to these towns of 5,000?
- Does the fact that most of the people of the United States listen to the same radio programs, see the same movie, and are subject to national advertising campaigns, mean that a town in Alabama is indistinguishable from one in Vermont or in Montana?
- What are the common denominators of life in these towns? Can they be significantly portrayed with the camera?

Such an elaborate plan to document life in the American small town is not now within our sphere of activity. We can, however, make the attempt to look for a set of

"common denominators" in the smaller towns which are encountered during the coming months in the field.

The following check outline is presented in the hope that it may be a help in finding these "denominators."

Our photo-documentation will be of a decided random sort. The photographer cannot stop to make an elaborate social and economic survey of the particular town he decided to "photograph." Our pictures can throw interesting light on life in the smaller towns of America.

The Small Town

A check outline for photo-documentation:

I. On the street

 A. General views of the main street (or streets). Choose these shots carefully to give an "over all" sense of the town.

 B. Buildings (representative)—Close ups of the more important buildings— these should include whole fronts, windows, and doors.
 Stores
 Theaters
 Churches
 Garages
 Shops—barber, shoe, etc.
 Restaurants
 Hotels
 Public buildings—town hall, jail, (cooler—
 calaboose) fire house, etc.
 Details of the above—fire escapes, balconies, special signs, details of facades, awnings, etc.

 C. People on the street. Let these be quite representative. The shots should show faces, clothing and activities.
 Men loafing and talking
 "Saturday afternoon"
 Window shopping
 Women and children waiting for the men
 Men and women coming out of stores with bundles and packages—e.g., in country towns men carrying tools and harness out of hardware store
 Women pushing baby-carriages

 D. On the walk
 Sidewalk displays
 Fire hydrants
 Traffic signs

Curb signs
Crossings
Hitching posts

E. Street traffic
Cars and trucks—parked and in transit
Wagons and horses
Sprinkler wagons
Street cleaners
Loads on or in trucks—to show the nature of the products grown or
produced in the neighborhood, e.g., corn, potatoes, cattle, hogs,
cord wood, etc.
Waiting for buses and street cars
Traffic signals

II. Stores

A. Outside-window displays and signs

B. Inside—counters, goods on tables, shelves, and racks. Note the class of
goods on tables, shelves and obtain good photos of characteristic items,
e.g., "patent" medicines.
Clerks—close ups—how they dress
People being served
Posters and other ads
(Make photos in various types of stores)

III. Theater

A. Front view—details of ticket booth, displays, person selling tickets—note
signs in ticket booths (box office)

B. Groups buying tickets, looking at displays

IV. Banks

A. Outside views—people looking out of windows—signs on the windows

B. Inside views—people working in bank—close ups. Interesting views
might be obtained showing the activity in a small country bank.

C. The "banker" interviewing a farmer

D. Equipment

V. Other

A. Restaurants and cafes
Shots of windows showing menus and "specials" listed on window
Interesting pictures could be obtained inside showing counters, tables,
slot machines, cigar case, menus and posters on wall
Pictures of groups eating at counters and tables

People who work in restaurant (get picture of the sign Short Order on restaurant window)

B. Stores
 Ice cream parlors
 Shoe shops
 Harness shops
 Barber shops
 Drug and hardware store
 Notion store
 Seed and feed store
 Get a set of good interior pictures
 Pool halls
 Saloons and beer parlors
 Funeral parlor

VI. Hotel

 A. Outside picture
 Close up of people on porch
 Cars parked in front

 B. Lobby pictures
 Desk
 People sitting around (close ups)
 Signs and posters on walls

 C. Dining rooms

 D. Display room where traveling men display their goods. Watch for a display and get picture of local merchants looking over goods.

VII. Garage—This place has taken the place of the livery stable as the meeting place of the town loafers, the "men-about-town." Very interesting pictures could be obtained at the garage.

VIII. Filling stations—A good set of pictures taken over an interval of time would give some idea of the "life" which passes through the town. This may also be a "town meeting" place.

IX. People of the town at their work

 Pictures of the people of the town and what they do
 Editor of the local paper
 Town marshall
 Postman or rural mail carrier
 Butcher
 Plumber
 Barber

Druggist filling prescriptions
Blacksmith
Filling station attendant
Harness maker
Clerks

X. Transportation

The railroad station (See special shooting script)
The bus terminal
Street cars
Automobiles

XI. Church

People going to church
People coming out of church
People visiting after church

XII. Lodges

Lodge halls
Signs and window displays
Lodge celebrations

XIII. The "Square"—The common

Anything of special interest such as the band stand, comfort stations

XIV. Country club

A good set of pictures of the small town country club—the people who go
to the club—and how they amuse themselves.

XV. Recreation

As complete a record of recreation as is possible
Baseball—the ball grounds
Local football
Children at play, organized and unorganized
Picnics

XVI. Special celebrations

Farming events
Lodge celebrations
National and local holidays

XVII. Schools

The buildings inside and out
The teachers
The pupils—at work and at play—going to school

Special schools
The consolidated school buses

XVIII. Homes—A small but selected set of outside photographs of homes. Show the better home areas and the areas where the poorer people live.

Show types of homes
Frontyards
Backyards
"Down by the tracks"

XIX. Local industry—What keeps the town going? As far as time permits, a study of local industries would be of great value.

XX. Utilities

Water system
Light and power
Sewage disposal

XXI. Miscellaneous

Firebells, alarms, or signals
Hitching racks
Signs, traffic, welcome, service club, tourist, general signs
Waste dumps
Elevators in buildings (especially old ones)
Delivery of newspapers
Man or woman working in garden or mowing lawn
People sitting on porch
Women visiting, *"Our Backyard Fence"*
Washing on lines in backyard
Raking and burning leaves
Dogs running around streets
The cemetery
Vacant lots
Street peddlers
Unpaved streets—mud holes

Organizations That Provide Grants for Documentary Photographers

The National Endowment for the
 Arts
Visual Arts Program
805 15th Street, N.W.
Washington, D.C. 20506

The John Simon Guggenheim
 Memorial Foundation
90 Park Avenue
New York, New York 10016

The Rockefeller Foundation
111 West 50th Street
New York, New York 10020

National Press Photographers Asso-
ciation
School of Journalism
University of Missouri
Columbia, Missouri 65201

The Friends of Photography
Box 500
Carmel, California 93921

Fulbright—Hays Grants
809 United Nations Plaza
New York, New York 10017

The W. Eugene Smith Memorial
 Fund
International Center of Photography
1130 Fifth Avenue
New York, New York 10028

The National Endowment for the
 Humanities
1100 Pennsylvania Avenue, N.W.
Washington, D.C. 20506

References and Further Reading

Abbott, Berenice. New York in the Thirties. Dover Publications, New York, 1973.

Beaton, Cecil, and Gail Buckland. The Magic Image: The Genius of Photography from 1839 to the Present Day. Little, Brown, Boston, 1975.

Bosworth, Patricia. Diane Arbus: A Biography. Alfred A. Knopf, New York, 1984.

Bourke-White, Margaret. Portrait of Myself. Simon & Schuster, New York, 1963.

Bourke-White, Margaret, and Erskine Caldwell. You Have Seen Their Faces (1937), reprint. Dover Publications, New York, 1975.

Capa, Robert. Slightly Out-of-Focus. Henry Holt & Company, New York, 1947.

Cartier-Bresson, Henri. The Decisive Moment. Simon and Schuster, New York, 1952.

Contemporary Photographers. St. Martin's Press, New York, 1982.

Davidson, Bruce. East 100th Street. Harvard University Press, Cambridge, Mass., 1970.

Dixon, Penelope. Photographers of the Farm Security Administration: An Annotated Bibliography, 1930–1980. Garland Publishing, New York, 1983.

Doherty, Robert J. Social Documentary Photography in the USA. Amphoto, New York, 1976.

Frank, Robert. The Americans (1959), revised edition. Aperture, Millerton, N.Y., 1978.

Freund, Gisele. Photography and Society. David R. Godine, Boston, 1980.

Gernsheim, Helmut and Alison. The History of Photography: from the Camera Obscura to the Beginning of the Modern Era. McGraw Hill, New York, 1969.

Hurley, F. Jack. Portrait of a Decade: Roy Stryker and the Development of Documentary Photography in the Thirties. Louisiana State University Press, Baton Rouge, La., 1972.

Hurley, F. Jack. Russell Lee, Photographer. Morgan & Morgan, Dobbs Ferry, N.Y., 1978.

International Center of Photography Encyclopedia. Crown Publishers, New York, 1984.

Johnston, Frances Benjamin. The Hampton Album. Museum of Modern Art, New York, 1966.

Lyon, Danny. Conversations with the Dead. Rinehart & Winston, New York, 1971.

Meltzer, Milton. Dorothea Lange: A Photographer's Life. Farrar, Straus & Giroux, New York, 1978.

Newhall, Beaumont. The History of Photography from 1839 to the Present. Museum of Modern Art, New York, 1982.

O'Neal, Hank. A Vision Shared: A Classic Portrait of America and Its People, 1935–1943. St. Martin's Press, New York, 1976.

O'Neal, Hank. Berenice Abbott, American Photographer. McGraw Hill, New York, 1982.

Pollack, Peter. Picture History of Photography. Harry N. Abrams, New York, 1969.

Rosenblum, Naomi. A World History of Photography. Abbeville Press, New York, 1984.

Rosenblum, Walter and Naomi, and Alan Trachtenberg. America and Lewis Hine. Aperture, Millerton, N.Y., 1977.

Rothstein, Arthur. Arthur Rothstein's America in Photographs: 1930–1980. Dover Publications, New York, 1984.

Rothstein, Arthur. Photojournalism: Pictures for Magazines and Newspapers. Focal Press, Stoneham, Mass., 1979.

Rothstein, Arthur. The American West in the Thirties. Dover Publications, New York, 1981.

Rothstein, Arthur. The Depression Years as Photographed by Arthur Rothstein. Dover Publications, New York, 1978.

Sander, August. Men without Masks: Faces of Germany, 1910–1938. New York Graphic Society, Boston, 1971.

Strand, Paul. Sixty Years of Photographs. Aperture, Millerton, N.Y., 1976.

Stryker, Roy, and Nancy Wood. In This Proud Land: America 1935–1943 as Seen in FSA Photographs. New York Graphic Society, Greenwich, Conn., 1973.

Taft, Robert. Photography and the American Scene: A Social History, reprint. Dover Publications, New York, 1964.

Tausk, Peter. Photography in the 20th Century. Focal Press, Stoneham, Mass., 1980.

Weegee by Weegee. Ziff-Davis Publishing, New York, 1961.

Welling, William. Photography in America: The Formative Years, 1839–1900. Thomas Y. Crowell, New York, 1978.

Wolcott, Marion Post. FSA Photographs. The Friends of Photography, Carmel, Calif., 1983.